Using Interactive Imagework with Children

Walking on the Magic Mountain

Deborah Plummer

Jessica Kingsley Publishers
London and Philadelphia

The right of Deborah Plummer to be identified as author of this work has been asserted by her in accordance with the Copyright, Designs and Patents Act 1988.

First published in the United Kingdom in 1999 by Jessica Kingsley Publishers Ltd,
116 Pentonville Road,
London N1 9JB,
England
and
325 Chestnut Street,
Philadelphia PA 19106, USA.

www.jkp.com

Library of Congress Cataloging in Publication Data
A CIP catalogue record for this book is available from the Library of Congress

British Library Cataloguing in Publication Data
Plummer, Deborah
Using interactive imagework with children : walking on the magic mountain
1. Imagery (Psychology) in children
I. Title
155.4

ISBN 1-85302-671-9

Printed and Bound in Great Britain by
Athenaeum Press, Gateshead, Tyne and Wear

Using Interactive Imagework with Children

of related interest

Reflections on Therapeutic Storymaking
The Use of Stories in Groups
Alida Gersie
ISBN 1 85302 272 7

Child Play
Its Importance for Human Development
Peter Slade
ISBN 1 85302 246 2

Children's Stories in Play Therapy
Ann Cattanach
ISBN 1 85302 362 0

The Metaphoric Body
Guide to Expressive Therapy through Images and Archetypes
Leah Bartal and Nira Ne'eman
ISBN 1 85302 152 0

Contents

Acknowledgements

The stages leading to the writing of this book have been numerous and varied and there have been many people involved along the way. I would especially like to acknowledge the parts played (in date order!) by my parents, brothers and sister – who never seemed to tire of inventing stories for me and who lovingly respected my dreams – Sharon Jackson, who initiated me into the world of personal construct psychology; the tutors at Vaughan College, Leicester, particularly Kathy Nettleton, Delia Cushway, Euan Slater and Pat Hemstock who were so enthusiastic in sharing their knowledge of the use of imagery in counselling; and Tom Ravenette, whose workshop on using drawing with troubled children opened up exciting avenues for me. Dr Christine Page inspired me with her theories of the mind/body connection and encouraged me to develop new skills. Thank you for that.

Dina Glouberman showed me how to integrate and expand on my work with images in a way that changed my life quite dramatically. Her creative use of imagework and her sensitivity and encouragement have had a profound effect on my work and in my personal life. I will always be grateful for the guidance she has given me. My friends in the Imagework Association were extremely supportive when I presented an exercise from this book in its early stages and they have been instrumental in my determination to complete the project.

There have been many friends and relatives who have read the early versions of the manuscript and given me invaluable advice; my grateful thanks to my sister Jane Harper in this respect, and to Dina for suggesting amendments and additions to the chapters on self-esteem and facilitating imagework sessions. My heartfelt thanks also go to all the adults and children who have shared their experiences of imagework with me and have shown me what it is to have courage in the face of long-term communication difficulties. Finally, a big thank you to Alice and John Harper for their wonderful illustrations.

A DREAM IMAGE

I had a dream.
I took the dream and put it in my pocket.
I carried it around with me all day.
While I ate and walked and talked and worked –
I carried the dream.

It seemed a little restless.
People said – 'You seem different today
– Are you unwell?'
The dream stirred in my pocket.

At last I made some space.
I took the dream and put it in my space.
I watched as it spread itself out.
I talked with it.
I listened.
I took the gift it offered and put it
– in my heart.
I lived my dream.
And people said – 'You seem different today.'

Introduction

Using Interactive Imagework with Children is about helping children to use the creative power of their imagination as an aid to personal development. It is a book for parents of junior school children as well as for teachers, therapists and other professionals who work closely with this age group. By presenting a format for the use of imagery within a theoretical framework, I aim to encourage others to explore this invaluable and natural resource with the children in their care. The material represents a synthesis of all that I have learnt and found most useful in my personal and professional exploration of imagery. As a speech and language therapist, I have primarily developed or adapted the activities for my work with children who stammer; but their potential applications are much wider. Indeed, I believe that the majority of children can learn to use their imagination in order to develop effective ways of coping with stress and to be creative in their thinking and learning. As they begin to recognize and value their own abilities to deal successfully with difficult situations, they will also be able to make more conscious choices in life. This, in turn, will contribute to a stronger sense of self-worth and lead to a happier, healthier and more creative future. I also believe that adults play a vital role in supporting this process, and that, by actively promoting the constructive use of imagery, we can help children to maximize their creative potential from an early age. I am certainly not suggesting that we should attempt to curb the wonderful free-flow of imagination which so many children possess, but rather that we help them to understand that this natural ability can *also* be used consciously and constructively. Imagework (literally, working with images) provides a means for us to do this.

For ease of reference, this book is divided into two parts. In the first half I have outlined the theoretical background to using imagework with children. I have endeavoured to put this into the context of stress management and supporting children's self-esteem. Imagework is, however, 'first and foremost not a theory but a practice'(Glouberman 1992, p.59). The second part of the

book starts with a chapter on how to introduce and develop imagework activities. This is followed by detailed instructions for seven practical sessions in which youngsters are invited to visit the different levels of the 'Magic Mountain'. Each of these levels explores a certain aspect of personal development and there is a natural progression through the stages of the journey. When children have been guided through all seven of these in sequence, subsequent sessions can be presented in a more random order or adapted as needed (see Chapter 6: 'Guidelines for Facilitating Imagework Sessions' and Appendix A).

Throughout life we are constantly creating and recreating ourselves and *Using Interactive Imagework with Children* has that same potential for change and growth. In the language of images, I see this book as a tapestry – the frame and the background are both imagework, the pattern is woven from the multicoloured strands of my professional training, my experience of working with adult clients and with children and their families, my work as an adult education tutor and my own personal journey of self-discovery. Stand close to the tapestry and you see each part of it in some detail. Step into it and you experience the integrated whole. As you will see it is, of course, a magic tapestry and so the viewer becomes the weaver and each weaver makes a slightly different pattern, shaping it with their own coloured strands of experience and knowledge! I hope that you and the children you accompany on this journey have fun weaving your own imagework patterns together.

Note: when referring to 'a child', the masculine and feminine pronouns have been used interchangeably.

PART I

A Theoretical Background

CHAPTER 1

Images and Imagework

What is imagework?

The term 'imagework' was conceived by Dina Glouberman. Formerly Senior Lecturer in Social Psychology at Kingston University, London, Dina is a psychotherapist and founder/director of the Skyros Centre, Greece, and leads imagework training courses internationally. She uses the term to describe a particular way of working with images and refers to this work as 'in its broadest sense, a method of tapping into, exploring, and changing the images that guide our lives'.

> Deeply held symbols, of which we are not necessarily aware, structure our thoughts, feelings, attitudes and actions. It is perfectly possible to operate all our lives without ever investigating these internal images or programs, but then we will have very little choice about who we are and where we are going. (Glouberman 1992, p.2)

Imagework involves drawing on these images from the unconscious in order to more fully understand both ourselves and the world around us, and to enable us to make more informed choices about our lives. The process is interactive (involving dialogue with the images either internally or through a facilitator) and organic, allowing for its creative application in many different fields of personal and professional development. Because of its interactive nature, imagework goes beyond many forms of guided visualizations, where a facilitator will suggest all or most of the images to be used and the image-worker follows the suggestions offered.

Soon after qualifying as a speech and language therapist, I began to use basic guided visualizations with clients as a self-help method for inducing feelings of calmness and physical relaxation. Although adults and children alike responded very positively to this, I felt that there must be some way of expanding the techniques. My first introduction to something more akin to imagework was when I discovered the power of working interactively with

dreams. I was going through a period of particularly intense and vivid dreaming at the time which I found very unsettling. The feelings I experienced during dreaming were frequently 'spilling over' into my waking life and, of course, vice versa. I began to search out books on dream analysis and was drawn to the works of the Austrian psychoanalyst Carl Jung and also some aspects of the work of Fritz Perls who was the originator of Gestalt therapy. Fortuitously, the Adult Education Department of Leicester University was offering workshops and courses based on these approaches and I signed up with trepidation, hoping that I wouldn't be overwhelmed by group analysis! I needn't have worried – it was a gentle but nonetheless far-reaching introduction to the world of the unconscious mind.

There are two exercises which I particularly remember doing and which are relevant to imagework. One was based on the idea of 'focusing' – being aware of ourselves and our perceptions from moment to moment. I realized at that point how 'unaware' I generally was! Perls believed that awareness is vital for our psychological well-being:

> Fritz Perls...often said that gestalt is the psychology of the obvious. He believed that we can very effectively learn ourselves, and learn our best ways of dealing with ourselves, each other and the world, by becoming more aware of what stands out for us from moment to moment, right here in the present. (Houston 1993, p.10)

By being more aware, we can aim to discover the meaningful whole that is more than the sum of the parts of any given circumstance.

> Rather than try to change, stop, or avoid something that you don't like in yourself, it is much more effective to stay with it and become more deeply aware of it...When you really get in touch with your own experiencing, you will find that change takes place by itself, without your effort or planning. (Stevens 1989, pp.2–3)

Gestalt therapy utilizes many different methods for reaching an understanding of this 'meaningful whole', and one of these is to use imagery to initiate a dialogue between different elements. So, for example, if you are trying to resolve or better understand a difficult relationship issue, you might have an imaginary conversation with the person concerned. This would involve imagining that person seated on an empty chair or cushion in front of you. You would then 'become' her – literally shifting into her seat – and swap backwards and forwards until some sort of resolution or insight is reached. Or, as I learned to do in the dream workshops, you might choose an image from a dream and have a conversation with it to find out more about what it represents. I was

amazed at how powerful this exercise proved to be. As I stepped into 'being' the image from one of my dreams I felt an almost overwhelming sense of what it represented and how it related to a conflict of expectations in my working life. This enabled me to reach a more 'informed' decision about what I needed to do.

The idea of interacting with images was also used by Jung who, early this century, developed the technique of 'active imagination' for use in his practice, and encouraged his patients to use it as a self-help tool. In active imagination, the person 'invites' an image to emerge from the unconscious and then actively involves herself in that image. Jung found that when someone seriously began a journey of self-discovery using active imagination, her dreams began to decrease in number. He felt that this was because there was no longer any need for symbols from the unconscious to keep recurring during dreaming as the issues they represented were being dealt with (see, for example, Jung 1916). Unlike dreaming, of course, the person is fully awake during active imagination and her conscious self is therefore very much involved. However, the idea is not to direct the process but to allow the imagination to flow where it wants and work with whatever images arise.

Robert Johnson describes how by talking to your images and interacting with them in this way you invariably find that 'they tell you things you never consciously knew and express thoughts that you never consciously thought' (Johnson 1989, p.138).

Both of these ideas – focusing and interacting with an image in order to gain new perspectives – are an integral part of imagework. When I eventually came across Dina Glouberman's imagework courses and enrolled on the introductory weekend I found that imagework was a synthesis of all that I had been exploring and a great deal more besides! I subsequently trained as a practitioner and have used imagework both in my personal life and as part of my therapy with people who stammer ever since. For me, the organic nature of imagework allows for its natural adaptation for use with children, and *Interactive Imagework with Children* was duly born out of my experiences of using these techniques in individual therapy and with groups.

I don't quite see it

Although many people find that they can 'see' things in their imagination this is by no means the case for everyone. Some people may get a 'sense' of an image but not a clear picture. They may be more aware of the sound or smell or feeling associated with it. None of these experiences are 'better' than another and no matter how we experience images it is possible to train ourselves to become more aware of them and to create new ones for ourselves. Image-making is

something we all do quite naturally, even if we don't always realize it. Thought (and therefore images of one type or another) always precedes action even for something as simple as picking up the post from the doormat or opening a window. Take a few moments to explore your own imaginative abilities by trying the following:

Imagine yourself peeling and then chopping an onion with a sharp kitchen knife. Do you see the onion? Can you smell it? Can you imagine the texture of the skin and the different layers as you start to chop it? Do you imagine your eyes watering? Can you hear the sound of chopping?

Now try a few more images:

- A waterfall cascading down a mountainside;
- A freshly mown lawn;
- Stroking a cat;
- Waiting at a busy railway station;
- Attending an important interview;
- Holding a crying baby.

Which was your strongest sense – touch, sight, sound, smell? Were you aware of any emotions associated with the images? Perhaps you experienced a mixture of all these things but to varying degrees. Whatever you saw, felt, heard or smelt was, of course, in your imagination and the strength of each of your images will have been due, in part, to your previous experiences and memories. For example, someone whose main experiences of railway stations are of saying goodbye to loved ones is likely to have very different feelings or 'energy' connected with their images compared to someone who travels a great deal for pleasure and has a sense of excitement associated with train journeys. A freshly mown lawn could conjure up memories of pleasant summers or it could perhaps engender feelings of discomfort associated with asthma.

In this way, even if two people have the same image they will experience it totally differently. Each person's imagery is unique to him. In effect, it constitutes his personal way of thinking on an intuitive, holistic level.

What is the unconscious?

In order to understand more about how children can make constructive use of imagery it is important first to examine some theories about the way in which the 'mind' functions. Muz Murray gives the following description:

Mind – which is a useful abstract concept to indicate all our modes of mental functioning – is not a *thing* in itself, but a fluid process, intermittently functioning at various levels. How we perceive life is determined by which level of consciousness we are operating through at the time. (Murray in foreword to Macbeth 1991, p.viii)

It seems that, rather like the visible portion of an iceberg, the conscious mind is only a part of what we might refer to as the total mind or psyche; a perhaps greater part, the unconscious, being below the surface of our immediate awareness.

Anthony Stevens, in his thought-provoking book *On Jung*, remarks that although the existence of the unconscious had already been established during the period 1700 to 1900, the investigation of its structure and function did not begin until the 1890s with analyst, Sigmund Freud (Stevens 1991, p.11). By the end of the nineteenth century certain propositions had been made concerning the unconscious. These included the idea that skills which we learn in a conscious manner, such as how to hold a knife and fork, eventually become automatic and transfer from the conscious to the unconscious. In addition to storing these automatic skills, it was postulated that the unconscious acts as a storehouse of numerous other memories and perceptions and that, while they are not always available to our conscious mind, these memories and perceptions can nevertheless affect the way we go about our daily living. For example, have you ever felt uncomfortable with someone for no obvious reason? It may be that they 'remind' you of an unpleasant encounter with someone else, even though you are not consciously aware of this connection. Similarly, you may have experienced the effects of the unconscious when you have suddenly felt angry or sad about something and wondered 'where did that come from?' or 'it's not like me to get upset over that!' Of course, pleasant feelings can also be evoked by unconscious associations – a sound, a smell, or perhaps the sight of a certain object may trigger a feeling of happiness or contentment because of its link with past events.

There will also be many images and happenings in life which will enter our unconscious subliminally: we will not have taken conscious note of them in the first place, yet they are stored as memories and can be made available to the conscious mind – for example, in moments of 'insight' or after a period of deep thought.

The idea of exploring the unconscious in order to understand ourselves better; and thereby free ourselves from the restrictions of unconscious reactions, became the subject of great debate and research in the early part of this century. Sigmund Freud and Carl Jung found that the storehouse of the

unconscious could be directly accessed using a variety of techniques including hypnosis, dream analysis and free association (where a person expresses whatever comes to mind, freely associating one thought with the next). Using these techniques, they discovered that memories which have been repressed, often since early childhood, can be brought into conscious awareness. The potential dangers of denying or repressing the unconscious have been written about extensively (see Stevens 1991, p.17). Bruno Bettelheim a leading psychiatrist and child psychologist of this century, has written that when the unconscious is repressed, 'eventually the person's conscious mind will be partially overwhelmed by derivatives of these unconscious elements, or else he is forced to keep such rigid, compulsive control over them that his personality may become severely crippled' (Bettelheim 1978, p.7).

Jung further proposed the existence of a 'collective unconscious', believing that there are some images which arise during dreams and active work with the unconscious which an individual could never consciously have come across before, but which appear in all cultures. Such images include 'the wise woman', 'the trickster' and 'death' (Jung 1978, p.41). Jung was, in fact, responsible for reintroducing this ancient idea of archetypal images into modern psychology. Archetypes can be thought of as 'the deepest patterns of psychic functioning' (Hillman 1990, p.23). They appear in our dreams and in myths and fairy tales all over the world.

Although imagework can be used to explore these two elements – repressed memories and universal archetypes – as a self-help tool it is more often used to access the creative potential of the unconscious. This third aspect is of much greater significance with regard to this book.

'The 'flower' of creativity

Jung argued that the unconscious was much more than a 'mere depository of the past'. He described it as 'a living psychic entity which, it seems, is relatively autonomous, behaving as if it were a personality with intentions of its own'(Jung 1949, p.17). He pointed out that, in the same way that conscious material can be absorbed into the unconscious, so too new ideas can arise from the unconscious:

> completely new thoughts and creative ideas can also present themselves from the unconscious-thoughts and ideas that have never been conscious before. They grow up from the dark depths of the mind like a lotus and form a most important part of the subliminal psyche. (Jung 1978, p.25)

We have all experienced these 'creative ideas', although we may not have been aware of using any specific technique to access them. For example, when a

problem seems insoluble, switching conscious attention away from it and involving yourself in some other activity (going for a walk perhaps) can often result in a solution suddenly 'coming to mind'. Many people will have had the experience of solving a problem during dreaming or while meditating. You may have found that you have had sudden flashes of inspiration when you are practising relaxation techniques. The more deeply relaxed you are in both mind and body, the more likely this is to happen.

For most of the time, however, our minds are so full of thoughts and preoccupations that there is no space left for these creative ideas to emerge. Jessica Macbeth describes this neglected resource as 'untapped natural magic':

> And all the while, above, behind, and beneath this surface level of consciousness, there are amazing, powerful, magical things going on – obscured from our awareness by the busy activity on the surface. Genius lies beyond this surface, and we are usually too busy to notice it so we think we are 'ordinary' people. (Macbeth 1991, p.4)

And Dina Glouberman describes this aspect of the unconscious as 'the whole world of thoughts, assumptions, and intuitions that we almost know but cannot quite formulate or utilise' (Glouberman 1992, p.29).

It seems, then, that the unconscious is a storehouse for previous experiences and perceptions and that it also possesses a creative function which is 'limitlessly productive of dreams, myths, stories, images, symbols and ideas' (Stevens 1991, p.16). The unconscious has great power and a wisdom of its own, and it is on this premise that imagework is founded. If our conscious, aware selves are only a part of who we are it is surely a waste not to learn to harness the creative power of the unconscious at an early age.

The role of images in early childhood

As we have seen, the imagination is one way in which a connection can be made between the unconscious and the conscious mind. In a sense the imaginative level exists at a meeting point between the two, a place where we can bring images and interact with them in order to reach a better understanding of ourselves. Constructive use of this level is an ideal skill for children to develop, since it is through images that children first start to make sense of the world. Before being able to understand and use verbal language, a young child learns about his or her environment through the perception and internalization of a multitude of different visual, auditory, olfactory and kinaesthetic – or 'felt' – images. Piaget (in Clark and Clark 1977) suggested that the ability to 'represent' actual objects and events internally is a 'necessary prerequisite for the acquisition of any system of symbolic representation for knowledge and

experience' (Clark and Clark 1977, p.301). Children need to have reached this stage (usually between one and one-and-a-half years old) before they can begin to use their first words, since words themselves are symbols which require the development of internalized 'images'.

For example, a very young child may use an approximation to the word 'cup' to indicate his own drinking cup, but not relate it to any other drinking vessel; and he may only use the word when he can actually see the cup in front of him. At a later stage in his language development, 'cup' may come to mean anything into which you can put food or drink. When the child learns that cups are similar in shape and are used for a specific purpose, he is starting to 'fine tune' the category 'drinking utensils'! Eventually, when he hears someone using this word he can 'imagine' the cup, link the word to the object in his mind. Now he can also have make-believe cups. He can give Teddy a drink from a toy cup or even from nothing at all, holding the air between his fingers as though he were holding the handle of a china teacup. The word becomes truly symbolic.

Expanding symbolic play

Symbolic play is an important part of a child's learning, not only in the development of language ability and abstract thinking but also in terms of social development. Through symbolic play children are able to formulate a sense of who they are and how the world 'works'. As they expand these play skills and begin to move into the realms of fantasy, children start to use their imagination to produce compensatory images to make up for what is lacking in their lives, and also to produce images to enhance the realities of life.

Images which arise during daydreaming or in this type of play are often symbolic expressions of feelings which may not be immediately available to their conscious mind. The need to show how they feel finds expression within the safety net of an imaginary scenario or imaginary characters.

> The symbolic play of childhood leads children to recapitulate emotionally charged experiences of their lives. Symbolic play involves spontaneous re-enactment of difficult situations that the child has been through. But play is completely voluntary. And no matter how difficult the content, it is fun. Here the child gets to control the situation; roles are often reversed. The process of symbolic play takes the child directly to and through the emotional core of the upsetting experience. Through playful re-enactment and further imaginative development, the overwhelming effects of the crisis emotions are modulated and transformed. (Chodorow 1994, pp.72–73)

Jerome Singer has suggested that some children have a stronger predisposition to fantasy than others (Singer 1973). He suggests that this predisposition is associated with certain characteristic styles of thinking and feeling. These include an ability to concentrate for longer periods, self-control while waiting, more numerous and more imaginative ideas when problem-solving and a tendency to be divergent thinkers (i.e. their thoughts diverge along a number of different paths in order to generate novel as opposed to stereotyped responses to problems). Divergent thinking is more closely associated with originality and creativity than is convergent thinking.

Perhaps for some children this creativity of thought arises partly because of their ability to tolerate ambiguity and contradiction – an important aspect of fantasy play. In fantasy the normal rules and associations about how things work in the 'real' world don't apply. Ronald Shone, author of *Autohypnosis*, describes this ability to dissociate oneself temporarily from the immediate environment as 'stepping outside' oneself and observing oneself, and being in other places simultaneously (Shone 1987). In hypnosis this means that when a suggestion is made such as 'your arm is heavy' the person who is under hypnosis does not 'associate' all the normal thoughts that go with the function of the arm and that might interfere with the suggestion.

As adults we make an enormous amount of associations to incoming stimuli. As we have already seen, these associations can be either conscious or unconscious. Being able to temporarily *dissociate*, however, is something we are all able to do, and is particularly evident during dreaming. It is an ability which can be utilized to very positive effect in imagework, in order to suspend logical thinking and allow the images to take on a life of their own. In the imagination 'normal' associations do not apply and images can do things which do not fit in with what is known or logical – a carpet can fly, a tree can walk, a child can defeat a giant.

The link with fairy tales

One particular type of fantasy, with which I'm sure many of us are familiar from our own childhood, is the ubiquitous fairy tale. Fairy tales contain a wealth of symbols which represent unconscious processes and children are naturally drawn to them for this very reason. Such tales have long been acknowledged as aids to helping youngsters (and often adults) to understand themselves and some of the dilemmas they face. Bettelheim, for example, suggests that some fairy tales get across to the child the idea that 'struggle against severe difficulties in life is unavoidable, is an intrinsic part of human existence – but that if one does not shy away, but steadfastly meets unexpected and often

unjust hardships, one masters all obstacles and at the end emerges victorious'(Bettelheim 1978, p.8).

One of the main attractions of using story-telling to help children to develop appropriate coping strategies is that they are 'one step removed' from reality: it is therefore possible to explore all sorts of scenarios in safety. Bornstein writes:

> When people listen to these stories they willingly suspend disbelief, as they would in nocturnal dreaming or day-dream activities; strange coincidences, morphological transformations, and other magical phenomena are accepted as normal events. Symbolism is the language of the unconscious mind, imagery is more emotionally evocative than language-based thought. Thus people are drawn into the stories and become emotionally and mentally engaged very rapidly. (Bornstein 1988, pp.107–8)

Although the fantasy itself is unreal, any good feelings that children experience from listening to fairy tales are more concrete. To quote Bettelheim again: '...by telling his child fairy tales, the parent can encourage him to borrow for his private use fantastic hopes for the future, without misleading him by suggesting that there is reality in such imaginings' (Bettelheim 1978, p.126).

Bettelheim also suggests that it is very important not to interpret stories for children because their meanings are so personal. If a child has taken a liking to a particular story it will usually be for a reason that he has not yet fathomed. It is important that the child has the chance to feel that he is the one who, by repeatedly hearing and thinking about the story, has coped successfully with a difficult situation. This is because 'we grow, we find meaning in life, and security in ourselves by having understood and solved personal problems on our own, not by having them explained to us by others' (Bettelheim 1978, p.19).

The way forward

How can we capitalize on this knowledge of how children use images? Constructive use of the imaginative process is such a vital part of a child's development and yet as we grow into adulthood the majority of us start to lose touch with this ability. We relegate the imagination to times of daydreaming and discourage our children with such comments as 'don't be silly, it's only your imagination'. We generally lose sight of the significance of fantasies such as fairy tales, and consider them unimportant because they don't involve reason. We tend to seek concrete information in different forms and rely less and less on our internal processing abilities. It seems that for most of us the imagination eventually becomes synonymous with things that are 'different'

from, and perhaps compensate for, the realities of life but which are unlikely to ever come true for us. This belief is reflected in some of the following definitions of the imagination given to me by a group of young teenagers:

'Pictures and stories and dreams that you form in your head.' *Chloe, 16.*

'Something that thinks things up the way you want them, not the way they are.' *Ruppa, 16.*

'The part of you that can make up anything you want.' *Stuart, 17.*

'Where your best things happen to you.' *Sharon, 16.*

'A place where bad things don't happen.' *Katie, 16.*

'A place inside you where all your dreams are kept.' *Frances, 15.*

It is surely time to rectify this situation, since the tools *are* available to help youngsters to realize some of their 'internal dreams'. I believe that imagework can play an important part in this realization. By valuing the wisdom of the imagination we can encourage children to use their natural image-making capacity to cope with potentially stressful situations, to help them to solve problems and achieve their goals, to increase their confidence and to help them to overcome the challenges they face in life. In short, to develop themselves. As Einstein said: 'Your imagination is your preview of life's coming attractions.'

The Interaction Between Mind and Body

Reading the signs

As part of my first post as a speech and language therapist I worked with adults and children who had persistent voice problems such as hoarseness or aphonia (loss of voice). Some of these difficulties had arisen because of prolonged misuse of the voice resulting in oedema of the vocal folds or in the formation of small nodules which were impeding the smooth production of voice. For others there was no discernible organic reason for voice changes: their difficulties were psychogenic – a symptom of some underlying personal struggle in life. Both types of voice disorder, however, illustrate the way in which the mind and body are constantly interacting. Even where such symptoms are organic in nature the question still arises as to why the person has developed a certain way of expressing herself that has resulted in physical damage. I became aware that many adults used language which mirrored their voice difficulties: 'I just can't tell you how I feel', 'It really sticks in my throat', 'I can't talk to him any more'. My interest in the mind/body connection was stirred, but not yet fully activated!

As with many roads of discovery in my life, it was not until I had a minor accident resulting in a month off work that I started to think about the interaction in more depth. I was feeling very stressed and had already spoken to my doctor about 'needing a break' from work. I took a two-week holiday on the last day of which I fell off a new bike, broke my arm and consequently needed three operations. A somewhat drastic but effective solution to 'needing a break'!

Some time later this mind/body connection was brought home to me again very strongly when I was working on releasing chronic tension in my back. During an imagework session I was asked to 'invite' an image which represented the pain to emerge from my unconscious, and then to get a sense of when this image had first been present. I explored the meaning of the image

and was eventually able to replace it with a much gentler alternative. I felt an immediate lifting of the tension and within a few days the pain, which had been with me for several weeks, had completely gone. I do not take the view that every single symptom that our bodies produce is a manifestation of our thought processes, but there is now such convincing evidence that our mind and body are so intimately connected that we cannot really separate one from the other in any discussion about how we function in the world.

Our posture, movements and breathing patterns, like words and pictures, can all be seen as ways in which we express our thoughts, and this includes the expression or manifestation of unconscious processes as well. Marilyn Ferguson, in her introduction to Gendlin's book *Focusing*, writes:

> Our brains and bodies know far more than is normally available to us–The central nervous system perceives and processes a great body of information that is stored outside the range of everyday awareness. Some of this information is best handled on an unconscious basis. But conflict, pain, and unresolved problems can become the source of chronic uneasiness, blocked growth, and even illness. (Ferguson 1980, p.ix)

One of the skills that most children learn quite early on in life is the ability to 'read' body language so that they can tell when someone is feeling anxious, cross, happy, sad and so on without relying on the words spoken by that person. However, although children learn to notice the tell-tale signs in others, they may be less aware of the way in which their own bodies reflect their self-concept and their emotions. Some children lose touch with their bodies at an early age, and have very poor body images or poor coordination. I am not talking here about a specific difficulty such as dyspraxia (a disturbance of the ability to produce coordinated movements due to impairment of the central nervous system) but rather a lack of awareness resulting from restricted experience of the feeling that they are in control of their bodies.

With this in mind, the following sections are concerned with looking at movement and breathing patterns.

Breathing

It's very easy to take our breathing for granted because it's an automatic activity and most people don't think about it on a conscious level. If you watch a baby or young child asleep you will see the ideal breathing pattern – slow, deep and regular. The stomach will be rising and falling easily and smoothly. However, breathing patterns can change, sometimes over long periods of time. These changes might be brought about by health problems such as asthma or occur as a reaction to prolonged stress or as a result of suppressed emotions (e.g.

'big children don't cry'). As well as these long-term changes, temporary changes will also occur at times of stress and reflect different emotions. For example, anxiety often results in shallow, rapid breathing (see Chapter 4).

Good breath control promotes a healthy mind and body. Calm breathing will help children to relax and allow images to emerge more easily. It will also show them that they can have some control over their bodies when they are feeling nervous or stressed and can help in dealing with potentially overwhelming emotions such as anger or fear. The exercise described below will help you to identify your own breathing pattern. Children can check their breathing even more visually by lying on the floor and placing a light book on their stomach so that they can see it rising and falling as they breathe.

> *Sit in a comfortable chair or stand in front of a full length mirror. Place one hand lightly on your chest and the other hand just below your bottom ribs. Take a deep breath in while watching what happens. Which hand moves the most? Do your shoulders rise? Does your stomach move in or out? Does your posture change in any way? Now breathe out and note any changes again. Keep in mind what happened as you now read through the following explanation of breathing.*

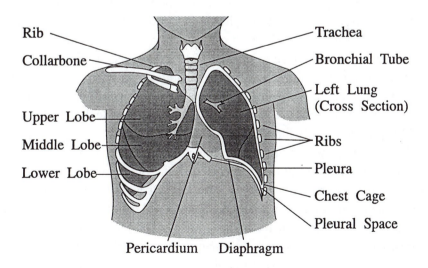

Figure 2.1 The lungs and chest cavity

The larynx forms the opening into the lower part of the respiratory tract and also contains the vocal cords which vibrate to produce sound. Below the larynx is the trachea which extends into the chest and divides into the left and right bronchi. These in turn branch to form a series of smaller bronchioles which conduct the air around the lungs. Below the lungs is a domed band of muscle called the diaphragm.

Breathing in (inspiration)

The muscles between the ribs (the intercostals) contract to elevate the rib cage and the ribs move outwards and upwards. At the same time, the diaphragm contracts and moves downwards. The dimensions of the thorax (the chest cavity) therefore increase. There is a thin membrane filling the areas between the lungs and the chest walls (the pleural cavities) which causes the lungs to adhere to the chest walls. As the chest moves, therefore, the lungs also expand. This causes a decrease in the air pressure in the lungs as compared to the air pressure in the outside atmosphere and consequently air flows into the lungs via the trachea to equalize the pressure. Inspiration is therefore an 'active' process, involving contraction of muscles.

Breathing out (expiration)

Expiration is normally a passive process. When the body is at rest, no muscular contraction is required to breathe out. Relaxation of the diaphragm and the muscles between the ribs allows the thorax, and consequently the lungs, to return to its original size. The rib cage moves down and in, the diaphragm moves upwards to its resting position. The elastic recoil of the previously stretched tissue creates a higher than atmospheric pressure within the lungs and so air is forcefully expelled in order to try and equalize this pressure with the outside. When an adult breathes in as much as possible the two lungs will hold approximately six litres of air.

We can increase the amount we inhale and exhale, and of course this happens automatically during vigorous activity. Breathing rates vary a great deal over the course of our lives. A new-born baby averages about 40–50 breaths a minute at rest. For an average ten year old this decreases to about 20. An adult at rest breathes in and out roughly 12–16 times each minute. Speech and singing require additional effort in order to maintain a particular volume, pressure and rate of air-flow through the vocal tract. Generally inspiration forms a much smaller proportion of the cycle of breathing than does expiration during these activities.

Ideally, when you were checking your own breathing pattern you will have felt the hand on your midriff move downwards and outwards when you breathed in. There will have been only slight movement in your chest. Your shoulders will have hardly moved at all and your posture will have remained balanced. This is diaphragmatic breathing. If you raised your shoulders and expanded your chest or pulled in your stomach as you took a deep breath, you were not breathing in a relaxed way. Diaphragmatic breathing is very natural but may take a while to relearn if your breathing pattern has changed over the years. Once children are able to direct their attention to the diaphragm they will notice themselves taking relaxing deep breaths during the day and this alone will help them to feel more energized and healthy.

Posture and movement

Breathing patterns are only part of the way in which we reflect our life experiences and the way we feel about ourselves. Wilhelm Reich, a psychiatrist and colleague of Freud, was an early pioneer in the study of the expressive language of the body. He believed that repressed emotions are stored in the body as chronic muscular tension, forming a sort of 'defensive armour' (Chodorow 1994, p.33). In this way our emotions motivate and shape the way that we move. For example, someone who has always suppressed their tears may have a permanently tense jaw. Someone carrying anger or resentment may have habitually tense shoulders. In a similar way to the alteration of breathing patterns, the muscle tensions become so chronic that the person themselves may eventually no longer be aware of it.

As early as 1916, Jung wrote a paper suggesting that expressive body movement is one of a number of ways of giving form to the unconscious (Chodorow 1994, p.1). He was aware that it could be used – along with other creative possibilities such as sand play, clay modelling, drawing etc. – as a form of active imagination. Dance movement as active imagination was later developed in the 1960s and is becoming more and more widespread in its use. Joan Chodorow, a dance movement therapist, highlights the significance of our early body consciousness. She writes: 'It is important to remember that the earliest experience we have of consciousness is through the body. Physical consciousness is the foundation from which we continue to develop psychologically'(Chodorow 1994, p.37).

An important figure in the growth of dance therapy was Laban. He believed that to be a fully developed and integrated person it is necessary to have a full movement 'vocabulary'. He felt that most of us have a very limited vocabulary of movement because of the way we live and the restrictions we impose on ourselves or which are imposed on us by others. Laban argued that by

increasing the range and depth of our movement possibilities we also increase the depth and quality of our growth as people and our ability to understand and relate to others. To take a simple example, someone who habitually walks with small steps can be encouraged to experience what it is like to take larger strides, or someone who has a heavy footstep might try walking with a 'light' step. This principle can be used in imagework as well, enabling children to experience different ways of 'being' and to develop a better understanding of how their thoughts affect their body (for example, see Session 4).

I have incorporated a few very simple dance and movement exercises into some of the preparation sections of the planned sessions but the potential for extending this is almost limitless for those who are interested in this aspect of imaginative expression (see Appendix E).

'Mind how you go!'

So, the mind and the body are in constant communication with each other as different systems of the body respond to messages from the mind and vice versa. Images play an important role in this communication: for example, the imagination directly affects the autonomic nervous system (ANS) – that part of our nervous system which controls such things as heart rate, breathing, circulation, body temperature and digestive processes. The ANS basically helps to maintain the constancy of our internal environment (homeostasis). It innervates what are known as the 'smooth' muscles of the body, i.e. the automatic muscles (as opposed to the skeletal muscles which are under our conscious control), the heart muscle and glandular tissues. The system has two parts – the sympathetic and the parasympathetic. These have different effects on the organs of the body but they work in conjunction with each other. For example, when the heart rate increases there is a reduction in the inhibitory (heart slowing) effects of the parasympathetic vagus nerve and a corresponding increase in sympathetic activity which accelerates the heart. In essence the parasympathetic division of the ANS conserves body resources. The sympathetic division increases body activity and utilizes resources.

How can the imagination affect this complex system? If I tell myself to increase my heart rate or to sweat, I'm not likely to notice much response! But if I imagine a frightening experience vividly enough then my body will respond accordingly. If you think back to the exercises at the start of the book when you imagined different scenes, you may have noted that you had some physical sensations associated with the images. One image which invariably has an effect on me is that of cutting a slice of lemon and placing it in my tongue. This always brings an immediate rush of saliva! Perhaps there have been times when you have imagined something so vividly that it has felt as though you are

actually experiencing it? This can often be a pleasant experience but can also have a negative effect. For example, thinking about what might go wrong in our lives can produce feelings of fear, anxiety, tension or worry that may be as strong as or even stronger than, if the event had really happened. As Charles Tart points out: 'Your imaginings can have as much power over you as your reality, or even more' (Tart 1988, p.59).

Working on this principle, recent studies have highlighted the possibility of using images to effect positive changes in the body. Dr Karen Olness, Professor of Paediatrics, Family Medicine, and International Health at Case Western Reserve University, Ohio has demonstrated how image messages can have an effect in the treatment of migraines. She has shown that children who regularly practise a relaxation imagery exercise have far fewer migraines than children taking conventional medicine for the same purpose. She has apparently also used such imagery as an adjunct to conventional therapy for children who stammer. Olness, who uses biofeedback systems to show children how 'thinking' can affect their body, feels that it would be of benefit for every child, beginning at the age of six or seven, to have an opportunity to be hooked up to a biofeedback system in order to experience the realization: 'change my thinking and my body changes' (Olness 1993, p.78). There is also growing evidence that the mind can actually affect the immune system and the science of psychoneuroimmunology – which studies the biological links between the mind, brain function and the immune system – although relatively new, will have a lot to teach us about this reciprocal interaction.

Mind/body connections and self-concept

Because of the perpetual interaction between the mind and the body, if we believe something strongly enough we generally begin to experience it in our lives in actuality. For example, if I believe that I am 'shy' or 'clumsy' then I will have a picture of myself in any situation acting in a 'shy' or 'clumsy' way. I will not be projecting a positive image of myself onto future events and I will act in the way I imagined, so continuing to reaffirm this picture of myself. In other words, telling ourselves how 'badly' we are going to do in some activity may in fact lead to actual poor performance – our imagination results in a self-fulfilling prophecy. If, however, we can use the power of the imagination in a positive way we can begin to alter our personal futures and promote our development towards confidence and well-being.

By encouraging children to listen to their thoughts and feelings and to note how their imagination can affect their bodies, we are teaching them to value themselves and this will undoubtedly affect the way they interact with others and the way they deal with situations in the future. For example, inventing a

new 'role' for themselves in their imaginations – where they see themselves achieving a goal, being confident, assertive or whatever else they are aiming for – will enable them to experience a new way of acting and reacting and allow them the chance to realize a new set of potentials. This concept is already widely used by Olympic athletes, who often have a personal imagery coach. These athletes are taught that by imagining themselves performing at their maximum level they can improve their actual performances.

To help to reinforce this intricate mind/body relationship I have introduced a variety of movement and breath control activities in each imagework session. The theme is also an integral part of the mountain itself since I have used the image of the mountain as a metaphor for the human body. Each level of the mountain is linked with an area of the body and its mental and emotional connections as described in traditional Eastern medicine. I have chosen this symbolism because it makes sense to me in the light of my own clinical experience and it helps to anchor the stages of the journey through the mountain to different areas of self-development.

I would like to end this section by describing a personal image that arose some time ago when I was at a turning point in my life. I had just started a one-year sabbatical and I was visiting the Greek island of Skyros to take part in further training as an imagework practitioner. As I sat on the stone steps overlooking the bay late one evening I found myself questioning my abilities and direction in life. I asked my unconscious for an image and after I had relaxed as comfortably as I could an image flashed into my mind as clearly as if I was looking at it in actuality. It was a bag of pebbles from the beach (I had been collecting pebbles earlier that day because I was fascinated by how many of them were worn quite symmetrically to form little flat circles). I also often have fairly strong auditory associations to accompany my visual images and what went with this bag of pebbles was: 'I may not be perfect, sometimes I'm not even good, but I have a bagful of perfect possibilities!' It is this idea of 'perfect possibilities' that I feel we should encourage children to discover in themselves!

CHAPTER 3

Problem-Solving and Goal-Setting

Let's now look at some practical applications of imagework in the context of two very important life skills: creative problem-solving and the setting of goals.

Children of vision

Successful achievers have generally developed two very significant attitudes in the way they view themselves and the world. They tend to see problems as challenges rather than obstacles, and invariably *believe* that they can achieve. They therefore set themselves regular goals, never becoming complacent about where they are in life. They are also often able to combine an analytical, logical way of thinking based on knowledge and experience with a creative and intuitive approach to life's challenges. This creative element has not always been actively encouraged in our society:

> Most creative people feel that they have developed their approach despite, rather than because of, their educational experience. Few of us have had the benefit of the kind of multimodal educational system which would help us to develop that potential for effective vision which lies within all of us. (Glouberman 1992, p.39)

What a pity to have had that natural ability, to have lost it, and to need to struggle to regain it in adulthood! There are many adult courses now available, both in the business world and in the field of personal development, which endeavour to 'heal' the split between these two ways of thinking – logical and creative – because our society in the past has favoured the former over the latter. Although this imbalance is gradually being redressed, I feel that we still have some way to go in acknowledging our responsibility to nurture this more unified, holistic style in our children, particularly since they begin to form an idea about whether or not they are 'creative' at quite an early stage in life.

Logical thought is the province of the left side of the brain. We also use the left side for language, reading, writing, and mathematics. The right side of the brain, however, is mainly concerned with rhythm, imagery, recognition, creativity and intuition. Imagework is, therefore, primarily a right-brain activity. Being able to use both the left and the right halves of the brain when faced with difficulties means that children have a wider range of possibilities open to them, more choice and ultimately more freedom to realize their true potential.

An example

In order for you to get more of a feel for this concept I would like to invite you to now try some imagework for yourself. The following is a 'taster' exercise based on one of Dina Glouberman's more elaborated imagework formats. It primarily involves observation of an image rather than interaction with it. You will need to familiarize yourself with the instructions first or ask someone else to read them to you.

Think of a difficulty that you would like to explore, perhaps a problem at work, a difficult decision or something you are struggling to complete. Sit quietly for a few minutes and let yourself relax as fully as possible. Gradually close your eyes. When you feel relaxed allow an image to come into your mind that represents the difficulty. Don't force an image to come, just let it 'happen'. It might be an image of an animal, an object or a plant. Allow whatever comes to mind no matter how strange it might seem. Now examine the image very closely. Look at where it is, notice its relationship to its environment. Is it alone or are there other things around it? How does it look from all angles, from in front and behind, from above and below? Does this image move or make sounds? If it could talk what would it want to say to you? What is its history? Has it always been like this or was there a time when things were different? Find out as much as you can about this image, remembering that it represents your present difficulty.

Now imagine that it is some time in the future and that your difficulty has been resolved. How does your first image alter? Don't force it to change, just let things happen. Again, look at its environment, examine it from all angles. Is there anything there that you hadn't noticed before? What is the next step for this image? Where would it most like to be? If it needs to change any more, how will it change? Imagine this change taking place as you watch.

When you are ready allow the image to fade and gradually become more aware of your present surroundings. Take your time over this and

as you become more alert remain sitting quietly and see if you can 'map' your image onto your actual difficulty. How does the image relate to the problem to be solved? How do the alterations in your image relate to possible solutions? Sometimes the answer is clear, sometimes you will need to bring the image to mind over a period of days to make sense of it.

Drawing on the unconscious

Drawing is another way of accessing the unconscious and utilizing the right side of the brain. In a similar way to using visual images in our minds, drawing can also be used to look at different aspects of a problem or question and to create links between present and future. The following is an exercise I was shown at a workshop run by Tom Ravenette who used drawing extensively in his work as an educational psychologist. 'A drawing and its opposite' is suitable to use with older children but it is important to make the purpose of the task clear to them so that they are able to decide on their level of response. Ravenette suggests saying to the child, 'And if you do this it may tell us something about yourself which you had not thought of before'.

Sit quietly for a few moments with your problem or question in mind.

Using the above line as a starting point, turn it into a picture which fills a whole page. Don't think too deeply about it and don't worry about 'getting it right' just allow the drawing to emerge. Remember, fill the whole page, don't restrict yourself to one object but think about the background as well.

When you are satisfied that it is complete, look at it carefully and then draw a second picture which in some way represents the opposite of the first. Drawing an opposite means that you become more fully aware of what you originally created. Now look at these two pictures side by side and see how they represent your dilemma/difficulty/concerns. What associations do you have with the two images you have drawn?

Now draw a third picture. Draw anything you want to – the first thing that comes to mind. If this third picture represents three ways of solving your problem, what would those three ways be? (Adapted from Ravenette, unpublished paper.)

Sometimes, in fact more often than not, the solution to a difficulty does not involve an opposite extreme. When I first did this exercise my original picture was of a bus, crowded with people and luggage, trying to battle its way up a large hill and looking as though it would collapse at any moment (an apt symbol of how I felt at the time). The opposite was one person in a fast car taking the hill easily. Neither extreme appealed! And the solution? Less baggage and share the driving! This idea of a third alternative is well illustrated in the case of assertiveness. For example, someone who is very passive might think 'If I were more aggressive people wouldn't take advantage of me and I would be happier'. However, it may be that the skill this person needs to cultivate is assertiveness, not aggression! This is not midway between aggressiveness and passivity. It has elements of both but also has features which do not belong to either end of the passive/aggressive spectrum.

A second exercise involving drawing is to simply sit with your question in mind and begin to make marks on the paper:

> *If you are normally right-handed, try using your left hand for this. Use different colours and draw without an end product in mind. It need not look like any particular object but will in some way represent how you view the situation or how you are feeling. When you have finished give your picture a name. Now add something 'surprising'. Once again consider how this relates to your question and whether or not it gives you an indication of how you feel things might progress*

There will always be more than one solution to any problem. Creative use of the imagination can help children, as well as adults, to find the way forward that is most appropriate for their individual needs at the time.

Working towards a goal

Imagework can also be useful as an aid to setting goals – an important but often undervalued skill. A person who sets him- or herself realistic yet challenging goals and is ready and able to evaluate his or her own progress on an ongoing basis, will find a sense of direction and purpose and the ability to accomplish more in a short period. However, many children don't set themselves goals because they have had past experience of failure, or because they have heard too often that they will not be able to achieve them. The idea that this is now true ('I never manage to do what I really want') becomes their own self-limiting belief.

Children generally need help to set realistic goals without being overly ambitious. But how often have we encouraged our children to try out new things only to see them fail? Perhaps they lacked motivation to change or had no concept of how achieving the goal would affect how they felt about themselves. Perhaps they could not envisage the end result clearly enough. Imagery can be used very effectively in this by providing the child with an opportunity to project herself forward in time, in her imagination, and to see a positive outcome, consciously experiencing it and, in effect, creating a memory of an event as if it had already happened. This forward projection allows her to recognize where she is at the moment – how far along the road she has already travelled. It also allows her to discover some of the things that she will need to know in order to achieve her goal and some of the things she will have to overcome. In this way she will have a much clearer idea of what she is aiming for and will be able to recognize the resultant benefits (see, for example, Session 6).

Such imagery makes use of the 'as if frame', an idea derived from the work of Richard Bandler and John Grinder (1990). The 'as if frame' enables the gathering of information that is usually unavailable. It requires the suspension of judgement and reality in order to act 'as if' you had already achieved some desired outcome. I suggest that you now try the following activity. Once again, you may need to read through this a couple of times before starting or ask someone else to read the instructions to you. Have a large sheet of paper and some coloured pencils near by.

> *Sit quietly for a few minutes and let yourself relax as fully as possible... Gradually close your eyes... Allow your imagination to come up with an image for the question 'Where am I in my life right now?' This might be an image of an animal a plant or an object. Just allow whatever comes to mind.*
>
> *Now, in your mind, examine the image very closely... When you are ready open your eyes and sketch the image on paper... When you have finished sit quietly again with your eyes closed.*
>
> *Breathe deeply and relax. Allow an image to emerge for the question 'What is my next step?' Explore whatever image comes to you... When you are ready open your eyes and draw the image.*
>
> *Repeat this process for the following two questions: 'What is getting in my way/holding me back?' and 'What quality do I need to develop in order to get me through this block?'*

When you have drawn the fourth picture take some time to think about how these images relate to your questions. You might find it helpful to talk to someone about what you have drawn in order to clarify what it all represents. Remember though that no-one else can interpret your images for you. They are very personal and will trigger your own unique associations. Only you know what significance they have.

Keeping on track

One of the skills involved in goal-setting is being able to recognize when you have started to achieve your target. This is not always as obvious as it sounds. For example, a child might have a goal of feeling more confident with a particular group of people and could judge the achievement of this by perhaps saying more than he normally would or by being in the group without feeling physical symptoms of anxiety.

It is also crucial that children learn to take things 'one step at a time' and, as they begin to make changes and achieve their goals, to give themselves a 'pat on the back'. To begin with children rely heavily on recognition and praise from the people who are important to them, but it is an unfortunate truth that if children are exceptionally good at making changes then others may begin to take all their efforts for granted. They may stop remarking on how well the child is doing. They may even begin to expect the child to take more and more responsibility where once they would have helped out. Or they may continue to react to the child as though he had not changed much at all. Increasingly children have to rely on their own powers of self-motivation and this will be easier if they can see themselves achieving small steps.

A theory of development

Self-initiated changes are likely to have a greater impact than changes imposed by others but, for many different reasons, change of any sort can be extremely difficult to cope with. In the 1950s American psychologist George Kelly outlined a theory of personal development which we can use to look at the way we develop our beliefs about ourselves, about how the world functions and about change. Kelly suggested that each of us is a 'scientist' – a seeker of patterns and a hypothesis tester. He said that we test out our hypotheses (what we believe about ourselves and the world) by making experiments throughout life. Sometimes these experiments validate our beliefs and sometimes they don't, so we then either alter our beliefs or alter our experiments. In this way we

begin to perceive similarities and contrasts in our environment and so learn to predict or 'anticipate' events (see, for example, Kelly 1991).

Kelly called the basis of these anticipations 'constructs'. For example, I have a day/night construct. I know from experience that one follows the other and that they have different characteristics such as light/dark. I can therefore predict or anticipate that this will always be the case. All constructs have an opposite – we can't know what 'day' is if we don't have 'night' with which to contrast it.

Sets of constructs are linked together to form a hierarchical structure and in this way the use of one construct (because it is part of a system) implies the relevance of several others. To take the example of day and night again, one association or linked construct I might have with day is 'work' and for 'night' I might also have a construct of 'sleep'. Of course for other people this might be reversed or night could subsume the constructs 'restless', 'anxious' and so on.

The context in which constructs are used is also vital and we can never assume that we know exactly what other people mean by a certain construct unless we explore it with them in more depth. One way of doing this is to find out what their opposite is for a given construct. Let's say that Person A considers herself to be 'shy' and her opposite of this is 'outgoing'. She wants to become more outgoing and explores what it would be like to change in this direction by elaborating her construct of outgoing to see what that would involve. Person B also considers herself to be shy. Her opposite of 'shy' is 'conceited'. She has no wish to make changes in this direction and sees 'shy' as a predominantly *positive* characteristic although she feels that this construct does imply some others which are not so agreeable to her.

Kelly said that a person's construct system provides both freedom and constraint: the system is ever-changing, but at any one time we are limited to make choices within the structure we have invented for ourselves. We are not, however, prisoners of our past as there are always other pathways along which we can move so as to see ourselves in a new light. Based on this theory it follows that children's constructs about themselves and their abilities and about any difficulty they have (such as stammering) will have a profound effect on how they behave and relate to others and on their academic performance. Also, when children want to make changes they may well have important constructs which might be affected by this change or which might actually prevent the change from occurring.

Exploring or 'elaborating' the opposite pole can help to show the way forward. Furthermore, trying to stop doing one thing without first elaborating an alternative doesn't usually work very successfully! To take a simple example, imagine saying to a child: 'Don't drop that glass!' The image the child will have

in his mind will be of dropping the glass – and sure enough, that is often what happens. An alternative might be 'hold the glass carefully'. Here the child has an appropriate sense of what to do and is unlikely to let the glass fall.

As the exercise 'A drawing and its opposite' demonstrated earlier in this chapter, imagery can encapsulate constructs and their links remarkably effectively. Images often allow much greater insight than words ever could and imagework provides children with the opportunity to 'elaborate' alternatives, thereby facilitating the process of conscious choice and perhaps helping them to alter some of their less helpful constructs about themselves and the world.

Fear as an obstacle to change

What else might prevent children from making changes? One of the biggest obstacles to change is anxiety or fear and the main fears associated with change for many children are fear of the unknown and fear of failure. Kelly described anxiety as the awareness that the events with which we are confronted lie outside the 'range of convenience' of our construct system. In other words, the event has not been part of our previous experience: we can't accurately predict what is going to happen. Anxiety and fear are fed by avoidance. The more we avoid, the more fearful we become. To overcome this and move forward, we must actively experiment in order to extend the range of our experiences. Otherwise we will try to keep our world small and manageable, avoiding changes and becoming more and more fearful. Fear will tend to push us back to what we know best so that we then are able to predict outcomes and won't risk failure (even though what we know best may be detrimental to our well-being).

Guilt

Another obstacle to change is the feeling of guilt. Kelly described guilt feelings as arising when we feel we are about to, or have already, stepped outside the 'core' role structure that we have invented for ourselves. For example, if a child develops a core role of 'good' daughter/son and this role subsumes constructs such as 'good children always tell Mummy everything' or 'good children don't get cross' then they are likely to feel a disproportionate amount of guilt if they do something that threatens this core role such as if they keep a secret from their parents or if they feel very angry with a teacher. Guilt feelings can be very destructive. They go with the language of 'I should, I ought, I must' and may lead once again to avoidance of change.

Using imagework to tackle obstacles

Imagework can be used to help children to minimize the possible difficulties involved in change by giving them an opportunity to 'research' the risk in their imaginations. This will enable them to see the benefits of taking one small step at a time and perhaps to get a sense of what the possible outcome and benefits might be when they have completed their goal (see particularly Session 6).

Through imagework children can face some of their fears and put them into perspective, thereby allowing the possibility of creative solutions to any obstacles. In order to overcome destructive and unwarranted guilt they can be helped to 'reframe' the change ('What if you had already done this? See yourself making the change. What is happening?'). They can be encouraged to look at their dilemmas from different angles, explore what it would be like to act in a different way, or reach a compromise in order to make the change more manageable for themselves (see, for example, Session 6 and Appendix A).

As facilitators in this process it is important for us to recognize that obstacles to change are a form of self-protection and should always be respected as such. This means that we need to allow children the opportunity to work through any resistances in their own time and not because we think it would be 'good for them'. Obstacles are usually the best indicator of the most appropriate solution and this is often clearly illustrated in imagework. The following is an example of how this might work.

Sarah had great difficulty in making friends at her new school. Her attempts at joining in with the games played by other children were awkward and frequently misconstrued as interference. She was seen as 'different' and experienced people's reactions to her as rejection. Before long she gave up attempting to join in and would simply watch from the sidelines or involve herself in elaborate but solitary make-believe.

In imagework Sarah saw herself behind a huge brick wall. She could hear the children on the other side and she could sometimes see them through a little peep hole, but they could no longer see her. The brick wall felt strong and protective, shielding her from harm. Removing this wall would undoubtedly have been far too devastating for her, yet the protection was also compounding her isolation.

Sarah came up with some creative alternatives. She found that, in fact, the wall was not attached to anything at one end and would therefore allow her to make short forays to the other side and retain the possibility of a quick return if needed. She could invite one other child

> *to join her behind the wall to take part in a game of Sarah's choosing and then accompany this child back to the main group. If the wall was to be taken down one brick at a time she felt that she would need someone to help her and it would have to be very gradual so as to prevent it from collapsing completely and causing damage to herself.*
>
> *I could imagine Sarah eventually stepping over a much depleted wall sometime in the not too distant future!*

In brief, I am certain that imagework can be used to help children to be creative in solving problems and to support and encourage self-initiated changes. By being aware of some of the obstacles to change we can act as sensitive guides in this process, gently supporting children as they explore different possibilities.

CHAPTER 4

Children Coping with Stress

So far we have looked at how imagework can be used as a self-help tool to support children through some of the inevitable trials and tribulations of daily life. At this point it might be helpful to bring together the theories outlined in the previous chapters to see how they relate to the ways in which children cope with stress.

What is stress?

'Stress' is a word with which we are all becoming increasingly familiar. In everyday language it is generally used to indicate the negative effects of life pressures: 'I feel stressed out', 'I'm so stressed, I can't think straight', 'my migraines are getting more frequent because of the stress I'm under'. In fact, of course, stress is a natural part of our lives; and a certain amount of stress is useful and necessary. It is one of the factors which motivate us to achieve; it can be a stimulus for action and it is important for success in school, work, sport and play. Coping successfully with a stressful but potentially enjoyable situation (such as learning to swim or to climb trees) can be a real boost to a child's self-esteem. Jane Madders, a physical education teacher and physiotherapist, offers the following definition: 'Stress is the effort used to stir up the body to adapt to change. It is a reaction that prepares the body for vigorous action when danger threatens, whether the cause is real or imaginary' (Madders 1987, p.10). This, I think, neatly encapsulates the fact that stress can be positive and useful, but also negative and maladaptive if the body is 'stirred up' for prolonged periods or unnecessarily with no means of releasing the resulting responses.

The type of things that different children find stressful (their 'stressors') are very much dependant on personality. Each child will be able to deal successfully with different amounts of stress and will perceive stressful

situations in different ways in the first place. For example, what one child sees as exciting and stimulating, another may see as terrifying.

Young children inevitably face stress almost every day of their lives because they are constantly having to deal with new situations for which they have no previous reference. Without previous experience of the same or a similar situation, it is difficult to predict what will happen; and the inability to predict causes stress. This might be positive stress, spurring a child on to accept the challenges of the ever-changing world, or negative stress resulting, for example, from fear which is not addressed (see Chapter 3).

So, although children benefit from a certain amount of positive stress it should only be as much as they can cope with for their age, personality and emotional maturity. Managing stress effectively is just as important for children as for adults. By coping successfully with stressful situations, children will increase their own feelings of self-worth and well-being and will build up an invaluable tolerance for higher levels of stress which will serve them well in later life.

Common negative stressors for children include:

- Fear of, or actual, separation from loved ones. This includes the fear of being lost.
- School pressures, including exams and starting or changing schools.
- Unrealistic pressure for consistently high standards of behaviour and conformity to rules.
- Bullying, teasing, difficulty in making friends, ending friendships.
- Inconsistent or conflicting messages from parents (e.g. do as I say not what your mother/father says).
- Feeling 'different' in some way from their peers.
- Fear of 'getting things wrong'.
- Boredom.
- Illness.
- Low self-esteem.

Identifying personal stressors

Encouraging children to identify and name some of the things which they find stressful is an important first step in learning to cope with stress effectively. The following discussion topic can be used to help children to identify their stressors and would be relevant for incorporation into the expansion activities of any one of the imagework sessions.

Make a list of five situations which you find stressful and five situations you think children find stressful.

When you have completed your list talk to the group of children you are working with about the things they think are 'worrying'.

How do their lists compare to yours? Your lists will be very personal to each of you and might include a mixture of reasons for stress. An example of a stressful emotion would be difficulties within a friendship, while a physical trigger to stress might be continuous loud noise or being in a crowded room. Mental stress might be, for instance, studying for a test.

Older children will be able to discuss the types of things that might worry them in more depth. Encourage them to contribute to a discussion about how different aspects of stress can interact. How, for example, being on the receiving end of frequent teasing (an emotional stress) can make someone feel physically sick; how having chronic asthma can be both emotionally and physically stressful for some people; and so on. It is important to talk about both the similarities and the differences in the way we each cope with different situations.

Finish the discussion by brainstorming ideas for things that make the children feel 'good inside'. These 'feel-good' moments can be pointed out during the day and perhaps be written up on a class or group list and added to periodically.

The effects of stress

The negative effects of stress can manifest themselves in very different ways. Some children, for example, may withdraw into themselves; others may become uncharacteristically aggressive. There are also many normal reactions of which it is helpful to be aware. When we are faced with a potentially harmful situation our muscles tense for action. This is a reflex action which causes messages to be sent to the brain. The resulting stimulus precipitates the release of hormones to prepare the body for 'fight or flight' – in other words to enable us to fight the oncoming threat or to run away from it. The fight/flight reaction includes the following signs:

- The liver releases some of its store of glucose to fuel the muscles, so that they will be ready to respond.
- The heart pumps harder to get the blood where it is most needed, i.e. the muscles of the trunk and limbs, in preparation for greater

muscular effort. This may feel like palpitations and may also result in an increase in blood pressure.

- There is therefore less blood elsewhere so the skin often turns pale and the movements of the stomach slow down or stop (the cause of a sudden 'sinking feeling' in the stomach).

- The intestines tend to become more active and the salivary glands dry up. This causes the sensation of 'butterflies' or 'churning' in the gut, and makes the mouth or throat feel dry.

- Breathing becomes faster because the lungs must take in more oxygen more rapidly and also get rid of carbon dioxide.

- The usual mechanisms which deal with infections in the body would be a nuisance, so they are subdued. We are more likely to succumb to infectious illnesses after prolonged stress.

- The skin sweats because the body is likely to get overheated in vigorous activity.

- The pupils of the eyes get bigger to let in more light and so increase sensitivity to incoming stimuli.

- The stress hormones, primarily adrenalin, are secreted to keep this stress reaction going.

We each tend to develop individual patterns of stress reaction, with some of the fight/flight responses being more pronounced than others. For example, some people habitually respond to stress with raised blood pressure, others with increased intestinal activity, yet others with profuse sweating, and so on. All these very normal responses occur because the body is preparing to face or run away from potential danger. If the reaction is completed, and the 'danger' dealt with, the body can relax again. Unfortunately, we often produce this reaction in situations which don't actually require a physical response (see the previous section on the autonomic nervous system). These things may happen even when we are just worrying about something without resolving it, when we are sitting in a traffic jam, or if we are concerned about a forthcoming test, a potentially difficult conversation or being late for an important appointment. Adverse reactions to stress can also occur when the original stressful situation is no longer there but we have done nothing to alleviate the stress response. Although the effects of poorly managed or excessive stress manifest in different ways, there are some tell-tale signs to look out for in children. Not all of these will be due to stress, of course; and they should be looked at in context of the child's general demeanour and behaviour:

- Tiredness.
- Disturbed sleeping pattern.
- Short temper and shouting.
- Listlessness.
- Weepiness.
- Difficulty in concentration.
- Reluctance to go to school.
- Fall in academic performance.
- Change in voice quality.
- Feeling of a lump or tightness in the throat.
- Persistent habits such as throat clearing or nail biting.
- Increase in hesitant speech (stammering).
- Change in eating patterns (an increase or decrease).
- Blurred vision.
- Headaches.
- Aching muscles.
- Abdominal pain
- Changes in behaviour e.g. becoming more withdrawn, more aggressive or unpredictable.

Handling the effects of stress

Most children, and indeed adults, experience some of these signs at different times in their lives; and they may not always be related to stress. They may be resolved spontaneously or the child and family may need specific help in controlling these symptoms and/or in tackling the situation which is contributing to their manifestation. Imagework can be used as part of this process as well as being available as a 'preventative' measure, enabling children to learn the skills to cope with potentially difficult situations in a more effective way (for example, see Sessions 2, 3 and 5 and Appendix A).

One of the main ways of successfully controlling the adverse signs of stress is through learning specific relaxation techniques. As I have already mentioned, I have incorporated relaxation exercises into the introductory parts of each imagework session as I believe that learning to relax mind and body effectively is a vital skill for children to acquire. Also, when children are relaxed

and their breathing is deep and regular they can reap the benefits of imagework more readily. Because the imagination is linked to the autonomic nervous system a period of relaxation prior to using imagework is helpful to inhibit the active side of the nervous system, allowing the images to emerge more easily.

Relaxation produces decreased metabolism, lower blood pressure and a lower respiration rate. Research has shown that it also produces the subjective feelings of calmness and stability (Benson, Kotch, Crasswell and Greenwood 1977). It is important to recognize that this is a skill that can be learnt and, as with any skill, regular practice is necessary to make it part of daily living. Benefits will not be immediate but will come gradually and will be long-lasting.

Relaxation techniques can be taught to children in a fun way, to relieve physical tension, to help them to relax emotionally and mentally, and to help them to feel at ease with themselves and with their feelings. It is also important to find an enjoyable relaxation method for yourself. If you don't already practise some form of relaxation on a regular basis you might like to try some of the ideas outlined in Appendix B. There is no substitute for experience! Your own relaxed breathing and relaxed posture will provide an important model for the children to follow and will, of course, produce long-lasting benefits in your own life. Don't worry about whether or not you are successful in achieving a deep level of relaxation straight away. Don't try too hard, just allow relaxation to occur at its own pace. When other thoughts come in to your mind, as they undoubtedly will, just acknowledge them and then go back to focusing on the relaxation method you have chosen. When you finish, sit quietly for a few minutes, first with your eyes closed and then with them open. Remember that the next thing that you do should be carried out very calmly. Take your time, move gently. Keep the relaxed feeling for as long as possible.

Of course, it is also possible to relax through active movement. There are various ways that children can experience this, which includes yoga exercises and creative dance. I suggest using this more active approach as a prelude to imagework with children who appear particularly fidgety or full of unused energy. Such techniques are also easily incorporated into the expansion activities and I have used some of these ideas in the session plans that follow.

A personal perspective on stress

My first career on leaving school was in the world of finance. I found the work stressful and had not yet learned about stress reduction and stress management! Subsequent forays into retail and clerical work were also stressful for different reasons. The early months at university created yet more forums for

stress-related symptoms to manifest themselves, and before long I realized that I was repeating patterns, set up in my childhood, of inappropriate ways to deal with life's pressures. Eventually, as part of my training, I was introduced to relaxation and stress management for clients. The ideas were a revelation to me and I thought then what a difference it would have made if I had been taught these simple techniques as a child.

Since that time I have tried many different methods both for myself and for my clients, and have found that personal preference plays a large part in what works for different people. My own favourites, naturally enough, involve images and using the rhythm of quiet breathing to focus my relaxation. When I can't sleep, imagining myself lying in a cushion-filled hammock in the shade of a tree on a hot summer's day invariably has the desired effect! Focusing on my breathing and imagining the flow of refreshing air 'sweeping out' my lungs and passing through my body helps me to regain tranquillity after a stressful situation. Children produce some wonderful images for relaxation – a whale floating quietly in the sea, 'eating jelly to relax my throat' (from a youngster who stammers), lying on a beach and listening to the sea, a gently flowing stream, a fluffy cloud – the possibilities are endless and such images can be used to facilitate 'emergency' relaxation when children are faced with particularly difficult situations. Be creative when teaching relaxation to children – giving them the opportunity to experiment with different formats will mean that they can build up their own personal repertoires for use now and in later life.

CHAPTER 5

Children and Self-Esteem

Session 3 of the journey on the Magic Mountain is focused particularly on self-esteem but this is a theme which is an integral part of all the sessions and deserves a special mention before ending this part of the book.

Anthony Storr writes: 'Confidence that one is of value and significance as a unique individual is one of the most precious possessions which anyone can have' (Storr 1989, p.96). Adults play a major role in supporting children's confidence and their fragile sense of self-worth, and imagework is one avenue for helping the development of this 'precious possession'. By introducing imagework into their daily activities, we can encourage children in their natural use of an holistic approach to life in order to reach a balanced understanding of the world with all its complexities of social interaction. However, we need to make this introduction in a sensitive and caring way, showing children that we value their feelings and respect them for who they are, not for what they can do. Before exploring how we can do this in practical terms, it might be helpful to first review some definitions of self-concept and self-esteem.

Self-concept

Robinson and Maines (1989) define self-concept as being a person's 'perception of his unique personal characteristics such as appearance, ability, temperament, physique, attitude and beliefs' (p.180). Self-concept is determined by the way we interpret the reactions or 'messages' from other people (i.e. the way we perceive their reactions to what we do and say) and this process begins with our earliest interactions as babies. Most psychologists agree that we generally try to act in a way that fits in with our self-concept. When new information is received to add to our system of beliefs about ourselves we may, therefore, use a process of biased scanning. This means that if the information fits in with our self-concept we will probably accept it as being true. If it is not consistent with how we see ourselves then we might ignore it,

misinterpret it or reject it completely. For example, we may deny our successes by saying that they were just chance or not really our doing. In this way our beliefs form a screen through which we see the world.

Even if we have concepts of ourselves which are not consistent with reality they are true for us because we *believe* them to be true (see also Chapter 3).

Self-esteem

If a person's view of himself is close to how he would like to be (his 'ideal' self) then he can be said to have high self-esteem. Self-esteem is concerned with the *value* we place on ourselves and is often unrelated to our true abilities. Alice Miller, author of many books on childhood, writes: 'The child has a primary need to be regarded and respected as the person he really is at any given time, and as the centre- the central actor- in his own activity' (Miller 1991, p.21). She goes on to say that the fulfilment of this need is essential for the development of healthy self-esteem and argues that children often suppress their feelings and needs in order to fulfil the desires of their parents, thus impeding their creativity and the development of autonomy and emotional strength. Anthony Storr gives us a salutary exposition of this suppression:

> Such a child comes to believe that continuance of his parents' love for him, and hence his security, depends, not upon being his authentic self, but upon being what his parents require him to be. Parents who induce this kind of belief in their children are often deeply concerned about their welfare, but are apt to demand impossibly high standards of 'good' behaviour, making the child believe that its instinctive drives and spontaneous responses are wrong. (Storr 1989, p.95)

So, high self-esteem is not necessarily dependent on success, but comes from a strong sense of self-worth, which enables children to cope with failures as well as successes. Low levels of self-esteem can lead to anxiety and confusion. Furthermore, whereas children with low self-esteem may act in a very passive way or may be aggressive – quick to get in first before they themselves are attacked (classroom bullies frequently have low self-esteem) – those with high self-esteem usually achieve more, are more willing to try new ways of doing things and tend to attract genuine liking and respect from others.

The role of adults

Children are most likely to have high self-esteem when the significant people in their lives are accepting and non-judgemental and when communication is

clear and unambiguous. I would like to explore this idea a little further as it is central to interactions with children of any age and is vital in imagework.

Being accepting and non-judgemental means showing children that we respect their ideas and that we take them seriously. Laughing at what children say or do, being sarcastic or making a joke about them, can have a devastating effect and will often be something that they carry into adulthood – 'I don't have anything worthwhile to say', 'My attempts at drawing are laughable' and so on. Children do, of course, say and do things which adults find funny and we need to be careful not to react too quickly to these instances. Children often respond to unwanted laughter by subsequent withdrawal or by anger directed at the offending adult, indicating how easily they can feel 'put down'.

Even when adults praise a child it can so frequently be followed by a qualification of some sort. Such qualified praise might go something like:

'What a lovely picture – but you've forgotten his eyes!'

'Well done for tidying up – why can't you always do that?'

'There, I knew you'd get that sum right – you just haven't been trying hard enough.'

Adele Faber and Elaine Mazlish, authors of *How to Talk so Kids will Listen and Listen so Kids will Talk*, point out that helpful praise comes in two parts: '1. The adult describes with appreciation what he or she sees or feels. 2. The child, after hearing the description, is then able to praise himself' (Faber and Mazlish 1982, p.176). One of the authors gives an example from her experience with her own child of four who showed her a page of 'scribble' that he had brought home from nursery school and asked, 'Is it good?' This is how she reports the conversation:

'Well, I see you went circle, circle, circle…wiggle, wiggle, wiggle…dot, dot, dot, dot, dot, dot, dot, and slash, slash!'
'Yeah!' he nodded enthusiastically.
I said, 'How did you ever think to do this?'
He thought a while. 'Because I'm an artist', he said.
I thought, 'It's a remarkable process. The adult describes, and the child really does praise himself.' (Faber and Mazlish 1982, p.176)

How does this translate specifically to working with images? It is important not to use evaluative words such as good or beautiful when talking about children's images unless this is how they refer to the images themselves. For one thing, what we may think of as a 'good' image might well be frightening or 'horrible' as far as the child is concerned! Also, instead of saying, for example, 'you're

very good at imagining' or 'you're brilliant at drawing' you might describe what the child has done: 'What a lot of different things you've put in your drawing. Your space ship looks like it's zooming through the sky and I can see that you've taken a lot of care putting in all the controls and using different colours.' Often it's possible to add a word or two that sums up the child's praiseworthy behaviour – 'Now that's what I call creative!'

Another way in which adults can support a child's self-esteem is by refraining from labelling. Notice the differences between the following statements: 'You're so naughty' as opposed to 'What you did then was naughty'. 'She's very shy' as opposed to 'She was a bit unsure of herself when she first arrived at the party'. In the first version of each of these examples the child has been 'labelled' as naughty or shy and will probably begin to absorb this idea as part of their self-concept if they hear it often enough. In the second version it is the action that is described instead. This recognizes the possibility of change if desired.

Valuing emotions

Being aware of the language we use with children is also relevant when we talk about emotions. In our culture feelings have generally been given values. They are 'okay' or 'not okay', but of course all feelings are *real*. Children may not be comfortable about the whole range of feelings they experience because they don't often hear adults stating how they feel and because they're often told *not* to feel certain things – 'don't be angry', 'don't get upset' and so on. As a consequence of this denial many children either 'bottle up' their feelings or stop trusting themselves and their own emotions. The message is 'don't listen to what you feel'.

If children are unaware of what they feel then eventually it will be expressed in other ways, and this will affect their contact with others. For example, an initial feeling after a difficult encounter might be 'I feel bad' but this might be expressed as anger (as in the case of reacting to an adult's laughter). Or a child may confuse justifiable anger with feeling hurt (denying the anger). Helping children to express how they feel may involve offering them 'feeling' words. During an annual intensive course for children who stammer we regularly brainstorm feelings and each group invariably comes up with thirty or more different words – many more than any individual child might actually use. I remember hearing about one young child who did a similar session with his teacher and was later found in the corner of the classroom stamping his feet. Clearly frustrated but unable to describe what he felt he turned to the teacher with a plea of: 'Give me a feeling word!'

It is one thing to feel comfortable with a range of different emotions but sometimes an emotion (such as anxiety) may be inappropriately intense. What can children do to overcome this? Either they can act despite their emotions (an extremely difficult task for adults, let alone young children) or they can try to alter the original thought that consistently triggers the anxiety. For example, it may be that they can say 'I am right to feel anxious about that situation – it isn't easy and my anxiety means that I can prepare myself well', or 'I can see that this isn't going to be so difficult and I don't need to be worried about it'. Useful, appropriate emotions engendered by realistic thoughts lead to positive action which reinforces the emotion and thereby the original thought.

How can imagework be used to support this process? One way is to help children to elaborate different roles for themselves, experiencing in imagery what it is like to be confident in a situation. Alternatively, we can help them to explore future possibilities so that they can minimize the risks involved in making changes (see previous discussion in Chapter 3).

Adults can further help children to understand their feelings by showing them that we can have some choice in how we *express* emotions (for example, anxiety doesn't have to be expressed by avoidance, anger doesn't have to be expressed by physical fighting). We can also help them to see that they do not have ultimate responsibility for how others feel. By this I mean that statements such as 'You make me happy' give them a lot of responsibility which is not really theirs. If they can make us happy then they can also make us sad – what a burden to carry! Consider the difference between the following statements in response to a child's perceived misbehaviour: 'You make me really angry' and 'I am angry'. Imagine yourself as a child and note the effects of these two ways of someone important to you expressing how they feel!

To summarize, supporting children's self-esteem involves showing them that we love, value and respect them for who they are, not for what they can do. It involves supporting them in their struggles and showing them that it is okay to make mistakes. It involves nurturing their skills by giving unqualified praise and unconditional hugs! I believe that it also involves celebrating their natural capacity for being creative and imaginative. *Using Interactive Imagework with Children* is my contribution to this celebration!

PART II

Stepping onto the Mountain

CHAPTER 6

Guidelines for Facilitating an Imagework Session

Whether or not you are already well-versed in using guided imagery or in facilitating groups, I recommend that you take time to read through the following points before embarking on an imagework session. Familiarizing yourself with these few guidelines will help you to feel relaxed and will enable you and the children to enjoy the process as fully as possible.

Introducing the idea of imagework

It is important to discuss imagework with the children before the first session. At a very basic level this might be simply a case of talking about having 'thoughts and pictures in your head that help you to work things out'. You might include the idea that imagework helps us to be inventive in how we solve problems, and explain how it can help us to feel more confident and how it gives us the chance to try things out in our mind before we actually do them. It is especially important to talk about what an image actually is, that it can be a person, an animal, a plant or an object and that some people will see images clearly and others will just get a 'sense' of it (see Chapter 1). Perhaps invite the children to imagine one of the images listed in Chapter 1 and then talk about how they experienced this, exploring any similarities and differences.

Making it 'special'

Here are a few suggestions which I have found to work well with groups:

- Make imagework sessions special by allotting a regular time to them, perhaps once a week. Like many important and useful skills in our lives it is often when we need imagework most that we tell ourselves we don't have the time! Ensuring a regular imagework 'space' in the

daily rush of life will have long-term benefits which far outweigh the initial time given.

- Take some time to prepare yourself and the room beforehand. I recommend that you read through all the stages of the Magic Mountain prior to involving the children so that you know roughly what to expect. There are some simple preparations which may seem obvious but which are easy to forget! Setting the music tape at the right place before the children arrive, making sure that you have a glass of water handy for yourself and assembling any materials you will need for the expansion activity can make all the difference to the smooth running of the session. Also, some of the preparatory activities and parts of the imagework journey involve a lot of movement. You will need to make sure that there is plenty of space so that the children don't feel restricted.

- Ensure that, as far as possible, there will not be any outside distractions or interruptions for the duration of the imagework.

- Use a specific method to signal the beginning and end of each session, for example by ringing a small wind-chime. This helps to define the boundaries of the activities as well as being a relaxed way to bring the children together.

- The ritual of these times can be further enhanced by choosing a 'special person' for the period that you are together. This is best done randomly, perhaps by putting names in brightly coloured sealed envelopes and asking the special person from the previous session to pick one. The special person can be given certain tasks and privileges such as putting away the tape recorder, being in charge of the wind-chime and helping to distribute materials for the expansion activities. I have a lockable box containing the 'Magic Mountain' book and each special person is responsible for getting the book out and locking it away again at the end of the session. He or she also wears a brightly coloured badge with 'special person' written on it!

Working interactively

Imagework lends itself to being highly interactive and this is especially true when working with one child or with a very small group (as a general guideline I have found that a group of six to eight children works well). When numbers are small encourage the children to tell you what they are experiencing at every

stage of the journey. You will find that I have suggested appropriate questions throughout each session. Verbal feedback of this type facilitates feelings of connectedness between group members and will help you to know what's going on so that you can pace your instructions accordingly. It also gives extra time to those who need to explore images more deeply or are having problems getting an image in the first place. Invariably the group will not all be working at the same pace. Move on when it feels right to do so.

The format can be adapted for use in larger groups by limiting the amount of verbal feedback you expect from the children and by using more of the suggested expansion activities. With large groups, when you are waiting for children to produce their own images, ask them to raise a finger rather than calling out to indicate that they have thought of one: this avoids disrupting others who have not yet formed an image. There is certainly no 'right' or 'wrong' way for children to do imagework. Positive encouragement may help them to verbalize what they are experiencing but it is important not to insist that they share something with you if they do not want to.

Allowing images to emerge

Children are usually very quick to perceive images but if they indicate that they are having difficulty you can help them by using any or all of the following suggestions:

- 'There is plenty of time. As you watch, just let the image (or pictures) come to you.'

- 'Don't worry if it's a little bit fuzzy to start with. It will fill out gradually as you go along.'

- 'Imagine that you are looking at a story book and you can see the pictures that go with the story you are hearing.'

- 'Don't worry if you can't see the images clearly. May be you can get a feeling about them.'

- If most of the group have indicated that they have an image you can reassure those who haven't by saying 'if your image hasn't yet appeared just wait for it quietly' and move the rest of the group on by saying 'for those of you who have an image you can begin to talk to the image in your head'. These prompts are unlikely to be necessary for the seven visits to the mountain, but are more pertinent when you reach the stage of developing imagework further (see the section 'Moving on' later in this chapter, and Appendix A).

Group gelling and group rules

Allowing children to participate in collaborative activities rather than simple question-and-answer sessions helps them to learn more and to develop a firmer level of self-esteem, as well as a better understanding of social skills. For most groups to work effectively, however, there needs to be some structure and a feeling of safety for the group members. With children's groups, the responsibility for enabling this naturally falls to the adult facilitator. If you are establishing a new group it is important to allow some time at the start for the children to get to know you and the other group members. This will help them to feel more comfortable about sharing their images and taking part in co-operative activities. The following are a few of the games that I use for facilitating this process.

- The children and adult(s) sit or stand in a wide circle. A soft ball is passed around and each person takes it saying his or her own name. After a few rounds of this each person says someone else's name before throwing the ball to that person across the circle.

- 'Fruit salad'. Everyone chooses the name of a different fruit. A caller is chosen and his or her chair is removed from the circle. The caller stands in the centre and names two fruits. The two people who have had their fruit called try and swap seats before the caller can sit in one of the empty chairs. The person left standing becomes the new caller. If the caller says 'fruit salad' everyone has to swap seats!

- 'Eye swap chairs'. The same rules apply as in 'fruit salad', but this time two people swap chairs if the person in the middle winks or blinks at them.

- 'Add about'. Everyone sits in a circle and someone is chosen to start off a mime sequence (it could be the special person who is chosen). The chosen child makes one simple gesture such as clapping, winking, touching his nose, clicking his fingers or stamping his left foot. The next person repeats this and adds on another gesture. This is a surprisingly difficult observation and sequencing game and can cause great hilarity, especially if each child has to keep her eyes closed until the person next to her taps her on the shoulder to show her the sequence!

- A quick and easy way to get to know a little about each other is to have a round of 'My name is_____ and I like_____'
(football, spaghetti, singing etc.). This can be extended by asking

each child to introduce the person on their right: 'This is_____ and he likes to _____ '

- Remember to include at least one verbal and one non-verbal activity to encourage participation by both talkative and quiet children.

It is also useful to establish a set of group 'rules' such as 'only one person talks at a time'; 'don't talk to other children during the imagework,' 'respect other people's images' (don't make fun of them) and so on. Allow the children to take a major part in formulating these rules, perhaps by brainstorming them together. It is important that they feel these are not constraints which have simply been imposed on them by an adult without any consultation. You could, however, encourage ideas by asking questions such as 'what do you think we should do when someone wants to tell us about their image?' (listen, sit quietly, try and imagine it as well and so on). In discussions following the imagery journey, children can be encouraged to take turns and to listen to the contributions of others by using a visual prompt. I generally use a shell which is collected from the centre of the group and then replaced by each child who wants to contribute. For more of a discussion between group members, rather than an account of experiences, children can be encouraged to direct their questions and comments to each other with the adult facilitator simply keeping things moving.

Whatever children contribute at these times or in any of the expansion activities, there should not, of course, be any judgement in terms of achievement no matter how weird or wonderful their ideas might be. Nothing that is said or produced during this time can ever be wrong. It is important that children understand this 'rule' right from the start so that they feel comfortable about making contributions. Drawing, writing, dancing, singing, discussing, making models etc. are all ways for them to express themselves freely and to experiment with their imagination in an environment which is non-judgemental and accepting (see also Chapter 5).

Notes on reading the text aloud

Each of the sessions in the following chapters is designed for use with individuals or small groups. In order to facilitate the flow of the text I have referred to 'the children' throughout the rest of the book. Please take this to mean the class, group or an individual child as appropriate. Each session will probably take at least 30–40 minutes without the expansion activities. Where there are a series of dots in the text this indicates that you will need to give plenty of time to let the children explore an image. Keep your voice as calm, smooth and quiet as possible both for the imagework sections and, of course,

the relaxation exercises. Also be alert for changes in each child's body language (posture, facial expression etc.) to give you an indication of how he or she is getting on. This will help you to pace the instructions appropriately and to be aware of anyone who is having difficulties. It can be very tempting to read the instructions as though reading a story and therefore to move through the session too rapidly. In order to prevent this from happening I suggest that you fully engage in the journey yourself, creating your own images at each stage.

Dealing with potential difficulties

The imagery of the Magic Mountain is designed to be as positive as possible, but just occasionally children may have an image that they don't like or which they have difficulty coping with. In group work you might want to pre-empt this by suggesting that children can do one of the following:

- They can leave an image at any time and simply rest, listening to the music and thinking nice thoughts of their own.

- They can use one of the images that they have already met on the mountain (such as Marigold or the Wise and Loving Being) to act as a protector or to perform the necessary 'magic' to help them through the situation.

- They can use their Safekeep (which they find on the first journey) to protect them from any harm.

Afterwards they will obviously need reassurance and time to talk about what happened. As adults we often find ourselves in the roles of teacher and/or protector and it can be very tempting to take on these roles when doing imagework. However, it is far more effective in this situation if we can be more of a 'guide' and trust the children to find their own solutions. In other words, it is important not to rush in and 'rescue' children from their images by supplying them with answers to their problems. Instead we can act as sensitive witnesses, supporting children as they find their own understanding of the images and their own way of dealing with them.

- For example, let's say a child suddenly encounters a frightening monster during an imagework session. If you are working with him on his own you could help him to deal with this at the time; but if you are working with a group the individual support may need to come later. Set aside a quiet time to show that you understand that what the child has to say is important and that you take it seriously. These are some of the questions and suggestions which you could

use in order to help the child to find what will work best for him (these also apply to helping children to cope with nightmares):

- Using the idea of the 'as if frame' (Chapter 1), encourage the child to imagine different scenarios as if they were possibilities – 'If the monster wanted to talk to you what would it say? If you could make the monster do something what would you make it do? If you had some special power, what would you do now?'

- 'Think of someone you know who you would like to come and help you' (perhaps a group of friends, a favourite uncle etc. but don't make the suggestion yourself, let him choose his own helpers).

- 'How will you make the monster less scary?' (for example, he might shrink it until it fits in his hand), or 'How will you protect yourself?' 'What will you do now?... And then what will happen?'

- Encourage the child to have a dialogue with the monster: 'Ask the monster what it wants. What do you want to say back to it? And what does it reply? What does it look like now?' (remember that in imagework children can tell monsters off and make demands of them or can negotiate with them: 'I'll play with you if you promise to stop chasing me').

- 'See yourself finding an answer to this difficulty...What are you doing that helps?'

- Use drawing to help the child to talk about the image. Suggest that he draws what he experienced and then that he adds to the picture or changes it in some way to show what he would like to happen.

- Knowing that they can leave an image at any time, some children will be able to 'become' the monster in their imagination in order to find out more about why it's there. As they step into being the image, ask questions such as 'What do you feel like? What is good about being this _____? [name the image] What is not so good? What would you like to happen? What do you want to say to ____? [child's name] For further ideas for questions, see Session 4.

Since monsters may represent an aspect of a child's current struggle or dilemma it is usually not a good idea for the child to kill it without finding out anything about why it's there or what 'message' it has. This would be equivalent to suppressing whatever it is that is causing the concern. Using some of the above suggestions you will find that children will soon come up with inventive

solutions which are all the more powerful because they have worked them out for themselves (see Chapters 1, 3 and 5).

These ideas are not just applicable to monsters, of course, but can be used in the exploration of many images. If a child finds himself in an unhappy situation during imagework and isn't ready to engage in it in any of the above ways, you might also suggest that he imagines himself rising above it and looking down on the scene so that his is not actually a part of it. He can then decide from that distance what he would change about the situation to make it okay; perhaps adding or removing something, or once again altering an image. Alternatively, he could bring in a time machine to take himself either to the point before the scary thing happened or after it has finished or gone away.

Remember, when you are helping children to elaborate on their images in this way always allow them to take the lead in deciding *what* to do and *how* they are going to do it even if you think there is an obvious solution. This also means using the children's own language, picking up on the words they use to describe the images and their feelings. Images don't respond well to adult intellectualization! They respond best to the language of a five-year-old!

The temptation to interpret!

When discussing the link between imagework and fairy tales (Chapter 1) I emphasized the importance of not interpreting these tales for children. This is such a fundamental principle to bear in mind when working with images that it really deserves a chapter on its own! The personal nature of images means that we cannot *assume* that they can be directly translated into a given meaning (rather like an 'image dictionary'). Every image is intimately connected with an individual's personal and cultural history (see also the discussion on constructs in Chapter 3). It would be intrusive and unnecessary to try and interpret another person's images and this is just as true when working with children as it is with adults.

> I have spoken of this elsewhere as befriending, and elsewhere again I have spoken of images as animals. Now I am carrying these feelings further to show operationally how we can meet the soul in the image and understand it. We can actively imagine it through word play which is also a way of talking with the image and letting it talk. We watch its behaviour – how the image behaves within itself. And we watch its ecology – how it interconnects, by analogies, in the fields of my life. This is indeed different from interpretation. No friend or animal wants to be interpreted, even though it may cry for understanding. (Hillman 1990, p.25)

When a person actively involves herself with an image or set of images for a while she is usually able to make a tentative 'mapping' on to actual life without the need for interpretation by others. She may experience an 'a-ha' sensation ('that feels right') which leads to a shift in perception and opens up possibilities for movement and change where none seemed evident before. This self-initiated change will inevitably have a more profound effect than change imposed by others.

In *Using Interactive Imagework with Children* the sessions provide a structure or scene in which children can feel comfortable enough to invite their own images to emerge. In this sense the imagework exercises have more of a guided visualization element than might be used with adults. Nevertheless, the children are encouraged to interact with the images in a way that will create their own unique outcomes and help them to trust in their own abilities to find solutions to their difficulties.

One word of caution. The material presented here is appropriate for use with the majority of children, including those who are already facing mild to moderate stress in their daily lives. However, accessing the power of the unconscious in this way is a powerful tool for change. If you are a therapist and you work with children who are experiencing acute stress then, as with any technique that can be adapted for therapeutic application, imagework should, of course, be firmly grounded in your own therapy knowledge. Imagework is not suitable for those few children who have a serious difficulty in separating reality from fantasy.

Having looked at some of the ways in which possible difficulties might be overcome, I hope that you will see that imagework can be remarkably 'healing'. Have trust in yourself, the children and the process!

The session formats

Each journey on the Magic Mountain is preceded by an activity to help the children to relax and to focus their attention. There are several alternative and complementary relaxation and breath control exercises detailed in Appendix B and Appendix C. Any one of these can be used either as an introduction to an imagework session or on its own. Deep relaxation can border on light hypnosis, and you should always take care to bring children back out of this very gently. If you have counted them down into relaxation then remember to count them back up again! Allow them a rest period for a couple of minutes after they have opened their eyes. Never rush them. Start the discussion or other expansion activity quietly and calmly, or, if you feel that they need to 'ground' themselves in the here-and-now, get them to stamp their feet and shake their hands as they open their eyes.

The preparatory stage of each session is followed by an imagery journey geared towards a specific aspect of self-development. The session is completed by choosing one or more expansion activities from a list of suggestions. These can be done immediately after the imagery or over a period of days before you take the children on the next stage of the journey. These expansion activities are a vital part of the process of imagework with children so please don't be tempted to leave them out! They are important because they help children to connect the inner world of images to the outer world of the here-and-now, and in this way to integrate what they have learnt into their lives.

Colour and music

There are two aspects of the imagery that deserve mention at this point. These are the use of colour and the use of music throughout the sessions. Colours are known to affect us physically as well as emotionally, and there has been much research into the optimum colours to use in hospitals, prisons, waiting rooms, classrooms etc. For example, studies have indicated that effective use of colour in factories can reduce accidents and absenteeism, increase production, and maximize job satisfaction. In traditional Eastern medicine different colours are associated with each 'energy centre' of the body and these colours are often used as aids to healing, meditation and visualizations. In *Using Interactive Imagework with Children* I have taken some of these principles into account and have used colour to enhance the strength of the images. I have found this to be particularly useful for children as it helps them to focus their attention and to remember the images later when they come to use them on their own.

I have also recently started to incorporate music into my use of imagework with children and I have recommended a selection of tapes to play in the background for each session. Some children love this, others find it distracting, so you will have to decide whether or not you want to use music in the light of what you know about the group with which you are working. Once again there has been much research indicating that different types of music can have differing physical as well as emotional effects on the listener. For example, there have been recent claims that listening to music by Mozart can affect performance on IQ tests and that listening to certain types of soothing music can affect pain perception (Robertson 1996). Listening to Gregorian chants also tends to have a calming effect and to increase energy, memory and concentration (Gardner-Gordon 1993). The tapes that I use have been chosen through a process of trial and error but are only suggestions and, of course, you may well find tracks that you feel are more suitable for your groups.

Moving on

In the introduction to this book I suggested that once children have become familiar with the Magic Mountain they can choose to visit different parts at different times. Sessions can then be adapted to fit individual needs. For example, the Book of Wisdom, which is found at the first level of the mountain, can be consulted for any number of reasons. The various people and animals that live on the mountain can similarly be revisited with only the briefest of introductions, such as 'close your eyes and relax... Take three deep breaths... and on the third breath imagine that you are at Marigold's home again'. Eventually, children will be able to use imagework on their own without necessarily going through a whole session. Brief imagework can be done on the bus, on the way to school, before going to sleep, before the start of a lesson, while waiting at the dental surgery – in fact almost anywhere and at any time when concentration does not need to be focused on other things. Some time ago I ran a workshop for colleagues on supporting self-esteem in children in which I talked about some of the aspects of the Magic Mountain. One of the participants recently told me that she regularly uses the HugMe tree which appears at the foot of the mountain – not just for children but also for herself so that she can deposit her worries before going to sleep! As you become more and more familiar with imagework you will find that you can adapt and experiment with the ideas I have outlined. To help you with this I have suggested a format for an imagework session geared towards a specific problem (Appendix A). I have taken teasing as an example but this outline can be used for many different themes.

Putting it all together

In summary:

- Children have a natural image-making ability which constitutes an important part of their social and emotional development.

- We are all able to 'think' in images and, in fact, images are constantly entering and arising from our unconscious mind. This 'below the surface' aspect of the mind acts as a storehouse of memories and perceptions and also has a creative function.

- Images from our unconscious influence the way we behave and relate to others. They can directly affect us physically as well as emotionally and mentally and are often symbolic of the 'constructs' we have formulated about ourselves and the world.

- The imagination can be used as a link between the unconscious and the conscious so that we can learn to understand ourselves more effectively and make more conscious choices in life.

- Images constitute our personal way of thinking and are generally dependent on an individual's background and experiences.

- We should not attempt to interpret images for children but we can help them to reach an understanding of what the images are trying to tell them (or, indeed, what they are trying to tell themselves!).

- As 'guides' in this process we need to be aware of how children respond to stress and to appreciate the role we play in supporting children's self-esteem.

So much for the theory. Now we finally reach the point of entry on to the mountain – good luck and enjoy!

CHAPTER 7

Session One: An Exploratory Journey for Confidence

Explanation for facilitator

The journey begins with an exploration of the base of the mountain. The colour associated with this area is red – the colour of vitality and strength – and, if we think of the mountain as being representative of our physical body, this would be the area at the base of the spine. The preparation, the imagework and the expansion activities take the themes of security, confidence and courage. The children are invited to begin their exploration of the mountain in safety and with the knowledge that they have a comforter or protector with them. They are introduced to the power of their own problem-solving abilities in the form of the Book of Wisdom and the riddle to be solved; they explore the feelings associated with confidence and they learn how to relax physically and to calm their minds when they feel agitated or unsure of themselves. Any gentle, relaxing music would be suitable to play in the background while you do this session. My own favourite is Kitaro's 'Morning Prayer' which has a magical quality to it, ideally suited to the point of entry onto the mountain (Kitaro 1985).

Once you have prepared the room, sit quietly with the children for a few moments just listening to the sounds inside and outside before you start.

Preparation

Today, because it feels like a special day, I'd like to share the Magic Mountain with you. This mountain is a place where people and animals live together and where magic is made every day without anyone thinking it out of the ordinary. Would you like to join me in a journey to the mountain? Then you could see the strange and wonderful images, hear the sounds of this world, smell the smells and explore the feelings. Do you think that might be fun?

Whenever we go on a journey we first need to get ready, just like when we prepare to go on holiday or get ready to go out for the day. So, let's begin at the beginning... To help you to enter into the world of the Magic Mountain you need to be relaxed... Find a really comfortable position to sit in, ready to let your whole body go loose... Let your body sink into the chair or cushion so that now you are as still as can be... Begin to think about your toes. Relax your toes and feel them getting warm and heavy... Let all the tightness just float away from your toe muscles so that they are not having to do any extra work... Now let go of any tightness in your legs. Put all your attention into your legs and let the muscles relax, release, let go... When your legs are relaxed begin to think about your tummy. Feel the muscles in your tummy go soft, relaxing and releasing any tightness that might have been there... Feel your hands and arms getting warm and heavy as they rest comfortably by your sides... Your fingers are very slightly curled but there is no tightness in them... Now think about your shoulders. It's easy to let our shoulders get tight when we're dashing about doing things all day, always in a rush. Gently raise your shoulders up towards your ears now and feel how the muscles have to work to keep them there... then let go... and feel the difference... Notice how it felt when they were tight and how it feels when your shoulders are more relaxed... Now let go even more than you thought you could... Think about your face. Feel a smile starting to come... Let the smile spread and spread until it reaches your eyes!... Now let go so that all the muscles on your face gently relax and your forehead feels a little wider and higher than it did before... If you haven't already shut your eyes, let your eyelids gently close now... Feel them become heavier and heavier so that you couldn't open them even if you tried... Notice your breathing. Be very still as you feel the air going in to your body when you breathe gently and quietly... Feel it as it slowly goes out again... in and out like waves on the seashore... In... and... out... in... and...out... Now forget about your breathing and just feel yourself relaxing more and more... Imagine that there is a red light flowing up from the ground... It is flowing through your feet... through your legs... your body... your arms... your shoulders... and your head... It floats away through the top of your head and drifts upwards... Now your body is still relaxed but your mind is awake and ready to go on the journey...

Journeying

Allow your imagination to take you to the Magic Mountain. It is very early in the morning. Even the birds on the mountain are still yawning and stretching their wings before setting off to find some breakfast. Imagine that you are standing at the bottom of this mountain ready to go on a walk... [*Wait a moment for the children to begin to get an image*] What are you wearing for this journey?... Look down and notice in your mind what you've got on your feet... It's going to be a long walk so you have some food in one of your pockets and perhaps some other things as well. Now start to look around you... what sort of day is it?... All around you there's a very beautiful green field. Maybe you can smell the grass or, if you listen really carefully, you might be able to hear the birds as they call to each other...or hear the little field mice hurrying along, swishing through the tall grass...If you're *really* lucky, you'll hear the rabbits as they burrow under the earth. Be very still and listen... In front of you there is a gate. Walk slowly towards it... It's a very special gate. Can you see what it is made of?... Is there anything growing around it?... What does it feel like when you touch it?... When you are ready, imagine yourself going through this gate and standing on the other side...[*Start to play your chosen piece of music very quietly in the background*]

Close the gate carefully behind you. You are standing on a path that leads up the mountain... Now, it would be good if you had something special with you to help you and keep you safe while you're on your journey. It might be an object, a plant or perhaps an animal. If you look around you as you stand by the gate and if you really take your time I think you'll see just what you're looking for. Look very carefully. When you've found it I'd like you to tell me what it is so I can see it too... That's good. You've got something very special there and, if you want, you can give it a special name. What would you like to call it?... So now, you take your [*use the chosen name or call it the 'Safekeep'*] with you and you start to walk up this very big mountain... Can you see what the path is like?... Is it going to be easy to walk along or difficult?... Carry on walking a little way, looking around you all the time... Now you can see that the path winds through some trees. Better make sure you've got your Safekeep. While your Safekeep is with you nothing can harm you and you'll be able to see what goes on and do special things. Take

some time now just to look at the trees from where you are standing…

Are you ready to go a bit further now? Let's take five steps. One… What did that feel like?… Two… What can you see?… Three… What can you hear?… Four… What can you smell?… Five… What are you feeling now?… Stand still for a moment and take a big deep breath… Breathe out with a long sigh. Feel yourself being as strong as the mountain itself… Now you're full of confidence and ready to go on. This part of the mountain is very quiet – so quiet that you could hear the tiniest thud of a ladybird landing on a leaf. There is an early morning mist swirling through the huge old trees all around you and there is a faint damp smell… The air is cool against your cheeks….. As you walk on you can feel the leaves crunching beneath your feet. The sunlight is beginning to make its way through the treetops so that little patches of light seem to be playing on the earth. In amongst the trees there are hundreds of red flowers just beginning to open their petals… Every one of these flowers is red, all the different shades of red that you can imagine, so that it looks like there is a thick red carpet here, soft and luxurious… Keep looking around you. See if you can tell where the path is going… There's a really enormous redwood tree just ahead of you. It's so huge that it seems to go on for ever up into the sky and the top of it has completely disappeared into the mist… If you stand right up against the redwood and touch the bark you'll find that it's warm and feels softer than you might think when you just look at it… It's very knobbly and the trunk is big enough for six people to join hands around it.

Keep very still and as quiet as you can and still have your Safekeep close by. You're going to wait for the Keeper of the redwood tree to come home. He has been out since before dawn, collecting food for his breakfast. Although the redwood is the largest tree on the mountain, its Keeper is only about the same size as you. You can see him coming now… What is he wearing?

As he comes closer, look carefully at his face. What colour is his hair? … What colour are his eyes?… He's smiling a little now… He is so near you I expect you can smell the woodsmoke on his clothes… He walks past you and stands by the side of the redwood tree. He says his name quietly and now he's going to say the password. *I* don't know what the password is but you might be able to hear it if you listen hard. He's going to try and say it really quietly,

hoping that you won't hear; but he has to say it loud enough for the redwood tree to open up its secret door. Wait a moment… Here it comes… Did you hear it?… Now you're standing where a door has suddenly appeared in the huge trunk… Take a good look at it and remember the password if you heard it because you may need it another time… The Keeper has gone inside and you can follow him in if you like. Take one step into the tree and look around. Look high up above you… What can you see?… I know it's not very bright in here but the Keeper is lighting a little oil lamp so now you can have a better look around. The lamp settles into a steady flame and now you can see more clearly. What does it look like inside this ancient tree?… Can you hear anything?… What can you smell?… What does the air feel like?… Touch the walls and see if they feel cold or warm… Are they smooth or are they knobbly like the outside?… Are there any pieces of furniture in here?… There doesn't seem to be any food around but you can smell something delicious. It smells to me like a cake cooking! The Keeper is holding the lamp out in front of him and he's heading for the far side of the tree where you can see there are some steps going down underground. You know you are perfectly safe so you can go down the steps as well. There are seven steps. Here's the top one. Count them as you go down. Seven… six… five… four… three… two… one… zero… Now you're in the main living area and the Keeper is busy seeing to the cake in the oven. You've got time to have another look around the room. Take a really long look… Notice all the bits of furniture… May be you didn't notice at first because it's tucked away in the corner but do you see the table at the far side of the room?… On top there's a pile of books and one of them is the most ancient of all books. It has pages and pages of ancient wisdom. This book contains answers to so many questions that it's thought to be one of the most precious books in the whole world. The Keeper is smiling at you even more now. He says that you can look in the Book of Wisdom if you like. Go over to the table in the corner and carefully look for the right book… Have you found it?… What does it look like?… Carefully open the cover and look at the first page. Do you see that it says 'Worries' in silver letters? Do you have a worry at the moment that you'd like to ask the book about? Have a think and see if there's anything you might like to know while you're here… Can you nod your head for me if you've got something you want to know? You don't need to tell me what it is…

[*If there is a worry*] – Now, if you put one hand on the book and whisper your worry it will be able to give you a little bit of help. You might have to wait for some time while it finds the right piece of wisdom to tell you but be patient and it will come. This book is so special that it can tell you things in all different ways. It might show you a picture or some writing or it might whisper back to you. So now you just have to keep looking at the book and wait. Will you tell me when you've got your answer? Thank you… Now, because it's very special to be able to talk to this book it would be nice to thank it for its wisdom and close it very gently.

[*If there is no worry*] – Okay, no worries today. May be you might want to come back another time to have a look. Close the book very gently.

It's time to leave now. You thank the Keeper for letting you look in the book and he gives you the lamp to help you see your way back up the stairs. Remember, there are seven steps. Zero… one… two… three… four… five… six… seven. You're at the top and you can see the great old door of the redwood. Walk quietly to the door and out into the daylight. Where is your Safekeep? Make sure you take it with you… Have you remembered the secret password so you can use it next time?… And now you're on the edge of the woods… and a little further on… at the bottom of the mountain… by the gate… Go through the gate and close it again behind you… And now you're back in the field. Take a big deep breath and let it go with a *big* sigh…

It seems like you've been on the mountain for a long time. Perhaps you're ready to go back home now?… That's quite easy to do from here. As you stand in the field take three more deep breaths… Now start to think about your toes and your fingers. Give them a little wriggle… Keep your eyes closed and feel how your body is gradually back in the room where you started. Notice the feel of your clothes against your skin and your body touching the chair… Still keep your eyes closed for a little while longer. Begin to listen to the sounds in the room and outside… Now wriggle your toes and fingers again and when you're ready have a big stretch and a yawn and open your eyes… And here you are back in the room! Just sit quietly for a while and then when everyone is ready we can talk about what happened.

SUGGESTIONS FOR EXPANSION ACTIVITIES

- Invite each child to draw something that she experienced during the imagework. She might like to start a 'journal' for these drawings – a record of her journey on the Magic Mountain.

- If the children chose Safekeeps which are easily recognizable, buy or make representations of them (e.g. a plastic animal or a paper flower). Keep them somewhere where the children can see them. This would be especially useful to have near the bed of a child who is prone to frequent nightmares. You could suggest to them that they can remember it's there if they have worrying dreams (see also Chapter 6 for ways to elaborate on this idea).

- Create a Magic Mountain out of cardboard and papier mâché. This can be added to after each session.

- Make a tape of the relaxation session with gentle music playing in the background. Individual children can then use this whenever appropriate.

- Draw a picture together of a time when each child felt very confident or courageous. A collaborative picture for the whole group can then be displayed on the wall.

- Help the Wizard and Grimes to work out the message in the poem on page 78. Make up your own poem or story together about being confident.

- Make up a collaborative story or poem. Each person contributes one word or sentence at a time. This illustrates the importance of turn-taking and is great fun! You could also discuss how easy or difficult it is if someone else completely changes the story that you had in mind when you started.

- Make a list of at least six activities that you enjoy. Now list activities that the children in your group or class enjoy. Ask the children to make lists of their own (or brainstorm ideas with the whole group). Think about what qualities attract the children to these various activities (and do the same for your own list). Possible headings might be:
 - alone/with others
 - indoors/outdoors
 - active/passive
 - challenging/familiar

- risky/safe
- relaxing
- funny/serious
- competitive
- thought provoking
- self-development
- creative
- other.

Can any of the activities which you and the children do at the moment be modified to include more of these qualities? Are there any new activities which the children could get involved in which would incorporate some of these?

A RIDDLE TO SOLVE

Long, long ago in magical times,
There lived a wizard and a cat called Grimes.
They lived in the woods on the mountain slopes
And wove their magic out of wishes and hopes.
They knew that the mountain had a secret to tell –
A magic much greater than the wizard's best spell.
But neither Grimes nor the Wizard knew where to begin
To look for the secret – without or within?
Then one day an ant came to visit the pair –
A wise little creature with a secret to share.
'I may not be big, I can't swim or jump high;
I'm not very strong and I can't even fly;
But I know that a clue to the magic that's here
Can be found, if you look, at the start of a cheer,
At the start of ourselves, at the start of each night,
At the beginning of friendships and some impish delight,
At the start of excitement, at the end of some fun,
Add the middle of peaceful and now I have done.'
'This', said the ant, 'is one thing that I've found
By talking and sharing and trying things out.
But now it is time to go further afield
Until more of the magical clues are revealed.'

CHAPTER 8

Session Two: Friendships

Explanation for facilitator

This part of the journey takes the children to the second level of the mountain, associated with the colour orange and corresponding in terms of our physical body to the area just below the naval. This area is associated with self-respect, relationships and sharing. At this level the children explore friendships and the feelings associated with having and losing friends. The preparatory section of this session is very short so that a greater length of time can be devoted to the expansion activities. However, if you feel that it is needed, a longer relaxation period can be used prior to the imagework (see Appendix B). The music I suggest for the imagework is Terry Oldfield's *Cascade* or *Radiance* by Philip Chapman (1990).

Preparation

It's that time of the day again when, if you are ready, we can go on another journey to the Magic Mountain. Let's start by getting ourselves relaxed. When you're comfortable, close your eyes gently. Just let them close, as though you were looking down at your cheeks and let your eyelids become so heavy that you couldn't open them even if you tried... Your eyes feel relaxed now and that nice relaxed feeling slowly moves down over your face... your arms... your body... your legs... and your feet... Every part of you relaxing, feeling heavy and warm, more and more relaxed. Now breathe deeply three times. As you breathe in, imagine that you are breathing in calmness and relaxation; and as you breathe out, let all the tightness in your body float away... Breathing in relaxation... Breathing out tightness... Breathing in relaxation... Breathing out all your worries... and once more... Breathing in relaxation... Breathing out tightness... Then coming up from the ground, imagine an orange light which travels through your feet... your

legs... your body, your hands and arms... your shoulders, your neck and your head... and out through the top of your head, floating away like clouds on a summer day. Now you feel very relaxed but your mind is wide awake and ready to go on the journey...

Journeying

[*Start to play your chosen piece of music*] Here we are in the field at the foot of the mountain. At the edge of this wonderful green field you can see the gate that leads on to the mountain path... Walk slowly to the gate, feeling the grass tickle your legs a little... Now you're at the gate. What does it look like today? Take a really good look at it. Notice its size, its colour, the feel of it when you touch it... If you look very closely you'll notice some pictures and shapes carved around the outside. Take some time to examine these carefully... What can you see? You can climb over the gate or you can open it: you can choose which you'd rather do... Now you're on the other side. Feel the warmth of the sun on your face... It's a beautiful morning here on the Magic Mountain. The sort of morning that maybe makes you feel warm and tingly inside because it's so special.

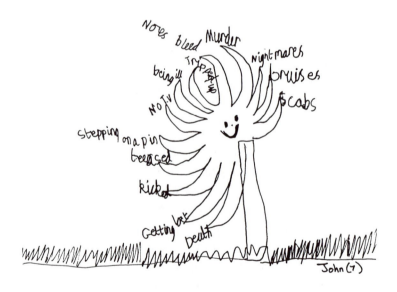

Figure 8.1 John's HugMe tree took away all his worries when he hugged it

As you look around, you'll see that on your right there's a great oak tree. Can you see it? It's stretching its branches out as far and as high as it can so that you will notice it... This is the HugMe tree. It's waiting for people who pass by to give it a hug. Hugging a tree is a special thing to do for both you and the tree. When you want to hug a tree, it will always let you! Imagine yourself hugging the HugMe tree now and feel what that's like...

Time to move on along the path that will take you up the mountain. You're going to go further into the woods today. You go past the redwood tree. Everything is quiet there. I expect that the Keeper is asleep... On the path ahead you'll soon be able to spot Marigold's home – Marigold is the white witch of the mountain. She makes lotions and potions and magic spells. All the wizards and animals and keepers of the trees know that Marigold makes special healing magic. Her home is very special too. You'll see it easily because there are orange flowers all around the front door and stretching way into the distance. There are some orange trees nearby as well. Perhaps her home is just around this next bend in the path? When you see it, can you tell me?... What does the house look like?...What is it made of?...[Help the children to elaborate on their image of this 'House of Friendship' as much as possible by asking questions such as: 'Has it got windows, a chimney? What is the door like?' It is important for them to have as clear an image as possible so that they can visit again whenever they want. You might also notice that this house of friendship changes slightly in appearance according to how the child is feeling and how they are coping with relationships]

Why don't you have a look round the outside before you knock on the front door? I know Marigold won't mind, and it's such a beautiful day to see all the orange flowers... What else do you see?...

Are you ready to knock on the door now and see if she's in?... The door is opening and there's Marigold smiling at you. What does she look like? What is she wearing?... Can you see the ginger cat by her feet? She's called Lila and she's come to say 'hello' as well! Wouldn't you know that most witch's cats can talk!

Marigold picks up Lila and welcomes you into her wonderful home. She's been making a potion for healing toothache (the poor Keeper has a lot of trouble with his teeth). She invites you to sit in her large cosy kitchen. There are big orange armchairs by the unlit fire. Of course, the fire isn't lit today because it's so warm; but it's

Alice(10)

Figure 8.2 'Lila' by Alice

cosy to sit here… Lila comes to sit near you, purring and stretching before she settles down. Marigold sits in the other armchair…

White witches are very clever. They know something about almost any problem that anyone might have, but they are particularly good at knowing about friendships. They know what people have to do to stay being friends with each other. They know how to help people make up again when they've had an argument. They know all about the good things that happen when people are friends and about how it's sometimes hard to find friends. They know that sometimes being someone's friend can be difficult as well as fun. If you have any question at all about friends, Marigold will be able to help you. Sometimes she knows straight away and sometimes she has to think for a long time before she can tell you. If you have a question, ask her now and wait to hear what she says… Let me know when you have your answer… Is there anything else you would like to say to Marigold?…

Marigold gets up from her chair and finds a jar of Magic Marmalade from her store cupboard… It's made from the magic oranges that grow on the trees outside her home. If you take a spoonful of this it will help you to feel that lovely warm feeling that comes when you have had a good day with friends or when a friend has said something nice to you or helped you. It's the same feeling that you get when you've helped a friend or been nice to them as well.

What does the marmalade taste like? ... What does it feel like in your mouth?... What are you feeling inside as you imagine yourself eating the marmalade?

Marigold puts away the jar again, but there is plenty there for another time. She gives you a small gift to take home with you. Imagine holding out your hand to receive the gift... Look carefully at what she has given you... What would you like to ask Marigold or say to her now?

I know that Lila is somewhere in the room. Can you see where she is?... She is a wise cat, perhaps the wisest cat on the Magic Mountain. If Lila were to whisper something special to you now, what would she tell you?... Take some time to have a little talk with her... Time now to thank Marigold for helping you... Imagine yourself going to the door and out in to the woods again... You turn and wave good bye to Marigold and Lila who are standing at the doorway... As you start to walk along the path back through the woods notice if anything here looks different now... You walk past the redwood tree and the Keeper is sitting outside. He smiles at you

Figure 8.3 John's jar of magic marmalade

as you walk past… You see the HugMe tree. Do you want to give it another hug?… You are back at the gate… You pass through the gate and in to the field. Find a spot to sit down in the field for a moment and just enjoy the sunshine… When you are ready, gradually begin to feel yourself coming back to this room. Notice what your body feels like… Notice the warmth of the room. Begin to wriggle your toes and fingers a little bit… When it seems right, open your eyes and have a big stretch…

Figure 8.4 'A magic cat' by John

SUGGESTIONS FOR EXPANSION ACTIVITIES

- Invite the children to draw a picture of something they experienced during the imagework.

- Have a small piece of fruit for each of them (e.g. an orange segment). Instead of eating it quickly, spend a long time tasting this one piece. Take tiny bits at a time. Hold it in your mouth and really savour the texture and taste. Do this in silence so that all your concentration is on the sensation of eating. Now spend time describing the feelings to each other. Think up as many descriptive words as possible.

- In the middle of a sheet of paper write the word 'friends' and put an orange circle around it. Draw some lines radiating from the circle. Along each line write one thing which members of the group think of as being important in friendships (sharing, trust, helping etc.) and also the feelings that are associated with friendships (warmth, happiness, sadness etc.). Although you may need to guide the children in completing this, try to include everything they say so that there is no judgement involved at this stage. You can talk about some of the ideas afterwards in more depth and perhaps highlight the ones that the whole group feel are the most important.

- Find a real HugMe tree to hug.

CHAPTER 9

Session Three: Self-Esteem

Explanation for facilitator

At the third stage of the journey the children visit the level of the mountain associated with the colour yellow and corresponding to the solar plexus area of the body just below the bottom ribs. Yellow is a colour linked with knowledge, novelty, mental agility and enthusiasm. Here the children explore feelings of self-worth or self-esteem.

The preparatory activity is once again fairly brief. It is an ideal activity as a preliminary to any 'quiet time', particularly if children seem fidgety or agitated. As before, if you feel it is necessary, you can extend the preparation to include a longer relaxation period. At the point where you settle the children ready to go on the journey, and throughout the rest of the session, I suggest that you play one of Mike Rowland's tapes such as *The Magic Elfin Collection*. Music by Philip Chapman, for example *Keeper of Dreams,* would also be suitable.

Preparation

When everything is quiet and we have a chance to sit together for a while it's a good time to go exploring on the Magic Mountain again. First we need to get really comfortable and get rid of any fidgetiness that we might have. Sit quietly for a moment and think about your hands... Imagine that your fingers are all animals or people, and that they're having a pretend play-fight. Make them play at fighting each other. Get them tangled up and then untangle them again... See how they scrabble with each other and squeeze each other!... Now let them slowly stop... and then make them float instead. Let your fingers float around each other without touching ... and now gently stroke your fingers across each other... Now have them fight each other again. They're moving faster and faster, really having a good tussle!... Gradually they slow down... Can you feel them tingling? Let your fingers gently float around each other again...

Sometimes, if you do this gently and slowly enough you will be able to feel the energy between your fingers, even though they are not touching. It feels like a tickle or like stroking silk. Can you feel that?... Have a little play with this energy. Imagine that you are holding a ball of energy... Hold your hands as though you have a soft invisible ball between them... feel the size of the ball. Move your hands closer together and further apart, all the time noticing the feel of the energy ball between them... Now let your hands rest comfortably as though they've gone to sleep. It's nice to rest quietly sometimes and to listen with the whole of our body, not just our ears. Let's see where our listening takes us today. [*If you are going to use music begin to play it at this point*]

Gently close your eyes and feel yourself relaxing all over so that every bit of you feels heavy and loose. When you breathe in you can feel a lovely warmth filling up your body. Each time you breathe out you are breathing away all the tightness in your muscles that you don't need when you are just listening. Feel the air as it very slowly goes in and out of your body... Imagine that there is a yellow light which is coming up from beneath your feet. It moves through your feet... your legs... your body... your arms... your shoulders... and your head... and it goes through the top of your head and floats away... So now you feel very relaxed but still wide awake and able to listen with every little part of you.

Journeying

Let's start at the gate at the foot of the Magic Mountain... By the gate is your Safekeep ready for you to take on your journey. Go through the gate and close it carefully behind you... Here on the Magic Mountain it is bright sunlight. All the colours seem brighter and more special today. Here is the HugMe tree again. Perhaps you'd like to give it a special hug before you move on?... Now you are going further up the path... Just ahead you can see the redwood tree. This time the Keeper is standing at the front of the tree. I think he likes to know that there is someone new visiting the Magic Mountain. Perhaps you could come back and visit him another time and ask him if you could speak to the Book of Wisdom again.

But, for today, you are going to carry on past the redwood tree and also past Marigold's cottage. You might see her ginger cat, Lila sitting amongst the orange flowers in the garden. Perhaps she's washing herself as she sits in a patch of sunlight... As you walk

further up the mountain the orange flowers behind the cottage begin to get fewer and fewer and instead there are masses and masses of yellow flowers carpeting the ground beneath the trees. There are primroses and daffodils and lots of other flowers of all different shapes and sizes… Take a little time to touch some of the flowers and to see what they smell like… Somewhere amongst all these flowers you will see one that is especially wonderful and different: one that you would like to have a closer look at. Take your time to find just the right one and when you've found it I'd really like it if you could tell me what your flower looks like… It sounds very special and I think it's the perfect one for you to explore inside. On the petals of this flower you'll see some dew drops which are sparkling in the sunlight. If you scoop these up in your hands and drink them they will let you become small enough to sit on the petals. Would you like to do that?

Okay, when you're ready gently collect up the dew and drink it… Imagine yourself getting smaller and smaller until you can step right into the flower… How does that feel?… What do the petals feel like when you touch them?… What can you see now?… Can you smell anything?… What can you hear?… You could curl up in the middle of this flower and let all the lovely yellow energy from it melt through your body… It's the sort of energy that helps people to feel really good about themselves… As you lie there surrounded by the yellow petals you could begin to make a list in your mind of all the things that you are good at… How many things can you think of? Can you tell me one thing that you're good at?…[*If you are working with a group ask the children to call out one thing each that they are good at. Encourage each child to think of things on their own but if they are having difficulties you might like to suggest things like 'drawing', 'riding my bike', 'making friends', 'thinking up good games' etc. Help them to think beyond the academic achievements for which they might have been rewarded at school*] Now tell me one thing you're really brilliant at…

Let's try and think of something we've done that was very brave. One of the bravest things I've ever done was [*describe something*]. Now it's your turn… You've done lots of brave things haven't you? It's hard to be brave all the time though and sometimes we need another person to help us when things are difficult or scary. If there is something that you can think of which is difficult or scary for you, you can ask the flower to give you some of its yellow energy to help. It always has plenty to give… [*Allow plenty of time for the children to ask*

questions] Even if there isn't anything you want help with right now, you know that you can always come back at any time and the flower will be here for you... What do you think the flower is feeling with you curled up inside it?... Imagine now that you can become the flower. Breathe into being this special flower that you have chosen. Take a deep breath and let it out with a sigh [*demonstrate this for the children*]. Now you are the flower and the flower is you. Each and every one of us is like a flower, beautiful and peaceful; but sometimes our flowerness gets a little tired and needs to be refreshed. Imagine yourself feeling the warmth of the sun on your petals and the feel of the air around you... Breathe in the refreshing air and breathe out any other feelings that you don't need right now. If you're tired, breathe out the tiredness. If you're sad or fed up, breathe out those feelings. Breathe in and out slowly and gently, feeling what it's like to be your chosen flower... Now, still as the flower, ask yourself: 'What is the best thing about being me? What is the best thing about being a flower?'... Now ask yourself: 'As this flower, what would I like to do most?' Look around you at the Magic Mountain. Would you like to be growing somewhere else or are you happy where you are?... Stay as this flower and see if you can look at your real 'self' [*or say the child's name if you are working with just one child*] curled up on your petals... What does your 'self' look like?... If you could whisper something to your 'self', something special and helpful, what would you whisper?... Now go back to being you, sitting on the petals ... Breathe deeply and really feel what it's like to be you inside this flower... Did you hear what the flower said to you?... Is there anything you would like to say back or anything you would like to ask?... Keep on talking to the flower and listening to what it has to say until it seems right to say goodbye...

Well, now I guess it's time to leave the flower. Begin to uncurl from inside the petals... and climb down onto the ground... When you're down on the ground again, give the flower a little shake and a tiny bit more of the dew drops onto your head – kersplosh! You can feel yourself getting bigger and bigger until you're back to your normal size... There! Don't forget to thank the flower for letting you have some of its energy...[*If the first part of this imagework has taken some time you might want to leave the following stage for another session*]

Let's take some time now just to look around this part of the mountain. Can you tell me what else you can see here?... Look down at the ground... Look up at the sky... Look to each side of you and behind you... Now let's do something magical. Imagine that you can float up very slowly above the ground to a place that's nice and comfortable for you, so that you can look down on this part of the mountain from above. Feel yourself gently rising off the ground. It's very safe and easy to do... Up you go... A little bit higher... And now you can look down at the ground below. Is there anything there that you hadn't been able to see before?... What is the best thing about being able to see things from above?... How does it feel different to being right up close to something like when you were inside your flower?... If you could fly like this whenever you wanted, what would be good about that?... What would be not so good about being able to fly?...

*Figure 9.1 John is sitting inside his magic flower and he can see
a magic bird*

Now imagine yourself gently coming back down to earth again... There you are, feet on the ground... And what's this right near your? A piece of paper with something on it. It's an award certificate, but it hasn't been filled in yet. I wonder who it's for? Imagine yourself picking it up. Carry it very carefully... It's time to go back home again now. You are walking along the path back through the woods... past Marigold's house... past the redwood tree... past the HugMe tree... and back to the special gate. You open the gate and you are in the field again... Imagine that you are lying down in the grass... You feel very calm and peaceful.... [*Allow the children a few minutes to enjoy the calmness*]

Just wriggle your toes and your fingers a little bit now and, with your eyes still closed, begin to come back to this room. Become aware of the feelings in your body and the sounds around you... When you are ready, give a big stretch and open your eyes.

SUGGESTIONS FOR EXPANSION ACTIVITIES

- Make a 'worry box' (an oblong tissue box is useful for this) with a hole cut in it so that the children can write or draw worries when they think of them and 'post' them into the box. Cover the box in bright paper or suggest that the children decorate it so that it looks special. The box could be emptied periodically and the worries discussed and then ripped up if the children feel they have been dealt with. There may be some worries to take back to the mountain on other occasions.

- Encourage the children to draw something that they have experienced during the imagework.

- Make yellow flowers out of tissue paper and display them on a table.

- Try and find pictures of as many different types of yellow flower as possible to make a collage. Talk about shades of yellow. Look at the different shapes of petals. Talk about where different yellow flowers grow (in gardens, by water, in the woods, on mountains etc.) and at what time of the year you can usually see them.

- Write a list together of all the things the children enjoy or which they feel they are good at. Try to get at least twenty things. Encourage each child to decorate the list using crayons, glitter, stars etc. to make it look extra special. Put it up on a wall where other people can see it.

- Fill in and decorate award certificates for each child to be presented on a chosen 'special day'(see Appendix D for an example). The other members of the group could decide what to put on the certificate while the recipient is out of the room. They then choose someone to present this very special award.

- Each child makes a list of 'Things I like about me'. For example, 'I like my smile'; 'I like my hair' etc. Encourage them to try and make them personal attributes rather than possessions (i.e. not 'I like my red jumper'). If writing is difficult then you could initiate a verbal round of 'I like...' in a circle.

- Plant some bulbs or seeds in a pot indoors. Let the children be in charge of watering them. Talk about the care that plants need in order to grow.

Session Four: Love and Self-Nurturing

Explanation for facilitator

Session 4 takes the children to a clearing in the woods where they can experience 'becoming' one of the creatures that live on the mountain. This area is associated with the colour green, which is linked to harmony and growth, and with both self-love and love of others. In terms of the physical body this area corresponds to the centre of the chest (although it is known as the heart centre, it is not actually directly over the heart). The imagework is helpful for children who need to be more in touch with nature, and has a similar therapeutic effect to stroking an animal when one is feeling lonely, sad or unwell. Whatever image each child produces, allow him to explore it as

Figure 10.1 Alice saw a rabbit and a fox

thoroughly as possible. There is no need to try and interpret his choice, although you may have some ideas as to the significance of the animal he meets. The preparatory session also incorporates a simple exercise on goal setting. The tape *Spirit of the Rainforest* by Terry Oldfield is ideal for the imagework.

Preparation

Before we go to the mountain today, we're going to do some stretching to get us ready for our journey. Find a space where you are not too near anyone else or near any furniture… Imagine that you are Marigold's cat, Lila. When Lila has been sitting still for a while, or when she's been asleep, she likes to stretch every bit of her, from her nose to her tail. See if you can stretch like Lila. Kneel down with your hands on the floor in front of you. Gradually begin to stretch your arms forward, walking your hands along the floor, feel your body getting longer and longer… Now bring your hands back to just in front of you and start to stretch out your legs behind you instead. First one and then the other… Now roll over and lie on your back on the floor and stretch out your arms, spread your fingers as wide as they'll go… Stretch out your legs and point your toes toward the other side of the room… Now let everything relax again… Gently roll over onto your side and then very slowly sit up. Now curl yourself up into a ball and when I say 'go' uncurl and stand up, reach up towards the ceiling as high as you can, really stretching your fingers upwards and standing on tiptoes. Go! Well done! Now relax again and slowly curl up in a ball. I want to show you how clever your mind is. Instead of really stretching this time I want you to *imagine* that you are uncurling and reaching for the ceiling. You can reach right up way above your head. You can touch the ceiling. You're so good at stretching you can go much further than you thought was possible. In your imagination feel what it's like to stretch that far. See yourself doing it… Good. Now I want you to *really* uncurl and stretch up and see how far you go… When you imagined doing this, you told your body that it could stretch much further than the first time you did it…and it worked!

Now relax, and give yourself a little shake all over. Shake your arms and your hands. Shake your legs and your feet, shake your shoulders, shake your body…Now you're ready to sit down and we'll carry on with the next bit of the journey. [*Start to play the music of your choice*]

Journeying

[*The idea of 'becoming' an animal and the questions asked at this point are adapted from 'Image as Life Metaphor' developed by Dina Glouberman 1989, p.87*] So – let your eyes gently close. With your eyelids closed raise your eyes up to the ceiling and hold them like that while I count to five. One. Two. Three. Four. Five. Now let your eyes drop... And now forget about your eyes... I'm going to count slowly from ten down to zero. As I count you will feel yourself getting more and more relaxed. By the time I get to zero you will be on the Magic Mountain again, near the yellow flowers that you've seen before. [*Count very slowly, gradually letting your intonation fall*] Ten... Nine... Eight... You're feeling very relaxed and calm... Seven... Six... more relaxed and very peaceful... Five... Four... You can see the Magic Mountain... Three... Two ... One... Zero.

You are on the Magic Mountain now and you can see that thick carpet of yellow flowers. The sun is shining through the trees and you can see the path ahead very clearly. It leads out of this part of the woods into a wide open space... Begin to walk along the path, feeling the warmth of the sunshine ... Ahead you can see the richness of the green grass in the clearing. As you walk towards it you can see that the trees surrounding this piece of open land are particularly green. The trunks are covered with bright green ivy and moss. The leaves are bigger and more shiny than you have ever seen before. Step right out into the middle of the patch of sunlight and you will see that there is a log for you to sit on. Here you can sit for a while and wait to see what happens... If you are very still some of the creatures of the mountain will come and say 'hello' to you. You might see some rabbits or a fox. You might see a deer or a badger. Perhaps there will be animals here that you've never seen before because this is, after all, a magical place. Perhaps some of the birds will come to see you. Sit very quietly and see who comes...What can you hear as you sit on this log?... What can you see?... Can you smell anything?...

The animals know that you are a special person and they feel very safe with you. They can feel all the love that you have, all the special feelings you have for them and for the Magic Mountain. They want to help you to feel what it's like to live on the mountain and they are inviting you to be one of them. Look around you and choose one of the animals that you would most like to know more about. Tell me when you have found one...

Who have you chosen? Well, now the [*name the animal(s)*] comes to stand in front of you. What do you notice about it? What colour is its fur or skin or what colour are its feathers?... What is its face like? What sort of a nose or a beak does it have? How big is it?... Now here's the really magical bit. If you slowly get up off the log and step forward you can become the [*name the animal(s). Encourage the children to physically get up and step into being the animal they have chosen, preferably while still keeping their eyes closed*]. Breathe deeply and become this animal – take a long, deep breath... and let go with a sigh [*demonstrate this for the children*] ... Now you are the [*animal's name*] What do you feel like? ... What do you look like?... How do you stand?... How do you move?... What sounds do you make? [*encourage the children to move and make the sounds of the animals*]... Really notice what it's like to be this animal... What are you doing now?... What can you see around you?... What can you hear? Smell? Taste?... What is the best thing about being you?... Is there anything about your life that is not so nice?... What do you wish for?... Is there anything you are afraid of?... Have you always been here or was there a time when things were different?... What would you like to happen now?... If you could wave a magic wand over your life how would you change it? Imagine something good happening that helps you to feel even better about being you... [*if the children cannot think of a way they would like things to change ask them what they especially like about being the animal they have chosen*]... If you could whisper something special to [*say the children's names or, in a*

Figure 10.2 John meets a magic fox

larger group, use the term 'your self] that would help them, what would you want to whisper?

Enjoy being this animal for a while, exploring the clearing, meeting with the other animals... [*The children can imagine themselves doing this or, in a group, you might want to encourage them to really interact with each other, opening their eyes and moving around the room as their chosen animal, stopping now and then to say 'hello' to the others or to play with them for a while*]

Now find a space of your own again. It's time to leave the [*animal*] now. Breathe deeply... Slowly step out of being your animal and sit down on the log... Breathe deeply into being you again... How do you feel now? Do you feel any different?... Is there anything you would like to say to the animals?

It was very special for you to feel what it's like to live here so it would be good to thank the animals, especially the one you chose. Any time you want to see them again you can visit the clearing and play with them or become one of them for a while. It would be especially good if you came to talk to them when you have a question or a difficulty which you'd like some help to solve. But you can come here just to have fun as well. They will always welcome you.

Figure 10.3 John meets some more magic animals

Are you ready to leave the mountain for today? I am going to count up from zero to ten and as I count you will feel yourself leaving the Magic Mountain and coming back to this room. [*Count very slowly with a rising intonation. If you have done this just before bedtime, leave out the words in the next part which bring the children to a more alert, wide-awake state!*]

By the time I reach ten you will be wide awake again, ready to open your eyes and feeling refreshed as though you have had a long sleep. One... two... three... Notice the feel of your body in the chair or on the floor... Four... five... Gently wriggle your toes and fingers... Six... seven... Feeling a bit more wide awake now... Listen to the sounds in the room... Eight... almost ready to open your eyes... Nine... feeling more and more awake... and...Ten! Open your eyes and have a big stretch and a yawn!... Stamp your feet on the ground to really wake yourself up.

SUGGESTIONS FOR EXPANSION ACTIVITIES

- Invite the children to draw something they experienced during the imagework.

- Encourage the children to 'become' different animals. Talk about what it feels like to be a lion, cat, monkey, snake etc. Experiment with the different types of movement associated with the animals – slithering, crawling, jumping; taking tiny steps, big steps, heavy steps, light steps. Move around the room freely, making large expansive movements, then feel what it's like to make very small, restricted movements in one area of the room. Talk about the good things associated with being each animal and the things that are more difficult.

- Link the preparation stage of this exercise (asking the children to visualize being able to stretch higher than they thought they could) with other activities such as imagining being able to run faster, remember how to spell words for a spelling test, imagining doing sums in their head and so on.

- Invite the children to contribute to a list of 'ways to look after myself'. This list might include such things as going for a walk, relaxing in a deep bath, having a 'quiet time', playing with the dog/cat, having a hug etc. Try and get at least twenty items on the list. Each child can then decide on up to three things that she will do when she is feeling worried, fed up or tired during the week. Help

her to be specific about this. For example: 'When I notice myself getting upset or up tight I will relax on my bed quietly, talk to a friend about it, ask Mummy for a hug.'

Session Five: Communication and Reducing Anxiety

Explanation for facilitator

At the fifth level of the mountain the children reach the magician who lives in the lake. The lake area is associated with the colour blue and, continuing the link with the physical body, it corresponds to the area around the throat. This level focuses on communication and creativity in self-expression. The colour blue is generally associated with calmness and with helping people to feel less anxious. The toning exercise in the preparatory activity is quite lengthy, and I recommend that you read through it a couple of times before using it with the children. Toning different sounds relaxes the body and induces a feeling of general well-being (see, for example, Goldman 1995).

A suitable tape for the imagework in this chapter would be Mike Rowland's *Silver Wings*.

Preparation

Before we go on to the Magic Mountain today, we're going to have fun with using our voices. We're going to do something that's called 'toning'. For this we need to get ourselves nice and comfortable. We need to have our backs as straight as possible [*the best position is to be seated cross-legged on the floor*] so that we are perfectly balanced and relaxed. Relax your shoulders. Put one hand on your tummy and feel what happens when you breathe. As you take a breath in, feel the air go all the way down into your lungs. Because your lungs need room to fill up with air, your tummy will come outwards, your shoulders will hardly move at all. Most people get this the wrong way round to start with! When you breathe out, your tummy will move inwards [*allow a few minutes for everyone to get the idea of this way of breathing*]. Now forget about your breathing for a while. Just let the air go in

and out without your having to think about it while I tell you about toning.

When we make different sounds with our voices they can help us to feel refreshed and well. Everyone can do toning even if they think they can't sing very well. It's fun and it's easy to do. When we make certain noises we can make different parts of our body vibrate or shake a little bit. Your voice comes when you vibrate the little tiny muscles inside your voice box. I'll show you what I mean. Place three fingers of one hand over your throat just where your Adam's apple is. Let them rest there gently. Now take a breath and let it out while you are humming... Did you feel your throat vibrate? Try that again... Sometimes we make sounds through our mouth without vibrating these little muscles. Gently place your fingers over your voice box again. Take a breath, and let it out as you say 'Sssssssssss'. You see, that time there were no vibrations! Now place your hands along the length of both sides of your nose. Hum gently and see what you can feel... Can you feel the vibrations inside your nose? When we tone and when we sing we are making our bodies vibrate all the time. All the tiniest bits of us are moving, jiggling around and helping us to feel good!

Now let's try a bit of proper toning. Begin by breathing in through your nose. Feel the air going right down to the bottom of your lungs and feel first your tummy and then your chest moving outwards. Now let the air go as you say the sound 'UH', as in 'huh'. This is a very deep sound but it doesn't have to be loud. Say it very gently and make it last as long as you can without running out of breath. In a moment we'll do that one again together. While you tone the sound this time, close your eyes and try to think of the colour red. It might help to think of a big red flower or a red blanket. Try and make the sound last for as long as possible, but stop before you begin to force your breath out. [*Make this sound three times in all*]

Now we're going to do the same with the sound 'OOO', as in 'two'. This sound is not quite as deep as the 'UH'. We need to make our voices a little bit higher and this time, we'll think of the colour orange. What could we have that would help us to think of orange? [*Make the sound 'OOO' three times as before*]

The next sound is 'OH', as in the word 'low'. It's a little bit higher than 'OOO' and the colour we're going to think of is yellow. Can you think of something nice that will help us to see yellow? [*Make the sound three times, remembering to keep the sounds long and gentle*]

Now we're going to make the sound 'AH' as in the word 'park'. While we're doing this we'll try and think of the colour green. What will help you to think of this colour? The sound needs to be a little higher than 'OH'. We have to make our voices go up a bit as though we are singing a higher note [*Make this sound three times*]

The next sound is 'EYE', as in the word 'my'; and the colour that goes with this one is blue. What would you like to think of for blue? Begin to tone this sound a little higher than the last one [*Make this sound three times again*]

Now we're going to move up to the sound 'AY' as in the word 'may'. The colour that goes with this is a very deep blue (indigo). Can you think of something that's got that colour in it? [*Repeat the sound as before*]

The last sound is 'EEE'; as in 'me'. This is the very highest sound we are going to make. Imagine this sound making the very top of your head vibrate while you think of the colour violet. [*Tone this sound three times. Because of the shift in energies that this toning produces you or the children may feel a little light-headed. You can sit and just enjoy this feeling for a while if you like but when you are ready to feel a bit more 'grounded' just tone 'UH' again three times*]

What are you feeling now?... I'm feeling [*say how you feel*] and I think it's time to go to the Magic Mountain again! Today we're going to visit a magician who lives in a lake. This magician can always help people with worries or difficulties. He's a very clever magician. He knows a lot about everything. So, first you need to think of something that you would like to ask him about. [*This part of the journey would be an appropriate time for children to seek help with tension-related problems such as headaches, stomach pains and bad dreams, or any concern over communicating with others such as reading aloud in class, speaking in assembly etc. If any of the children really can't think of anything this time you could say that the magician will be able to help them to feel even more of something e.g. happy, confident, energetic*]

Journeying

So, now we're ready to set off. Find a nice comfortable, relaxed position and when you're ready let your eyes gently close... Notice how your eyelids feel heavier and heavier and how gradually that feeling spreads all the way down your body – over your face and the back of your head... through your neck.... your throat relaxes... over your shoulders... your arms... your hands... carrying on down

your body… your back and your tummy… your legs… and your feet… so now every part of you feels heavy… and warm… and relaxed. We're going to go to a new part of the mountain today. Remember, when we were toning we thought of the colour blue while we made the sound 'EYE', didn't we? Can you remember what we thought of to help us to see blue?… Okay, see if you can think of that blue again while I count slowly from one to ten. I'm going to count upwards today to help you to imagine yourself going up the mountain. As I say each number, you will find yourself closer and closer to the spot where we want to be – the place just past where we were before in the clearing. You can get there without walking past all the other places we've visited just by wishing yourself there. Do you have your Safekeep with you?… One… two… You've started on your way… Three… four… five… Keep thinking of the colour blue… Six… seven… Wish hard!… Eight… You're nearly there now. Nine… A little closer… Ten. There! You're on the other side of the clearing now, standing on a new part of the mountain. Have a look around you and notice how different this part of the mountain is. Can you tell me what you can see? [*This is an appropriate point to start playing your chosen piece of music*]

Perhaps you didn't notice it to start with, but a little way ahead of you there is a very small slope downwards. Begin to walk towards it and you will hear the sound of water… As you reach the edge of the slope you will see that it leads down to a beautiful blue lake and there's a little waterfall splashing down into one end of it. The sun is shining on this lake so brightly that it looks almost silver in parts. It's the most beautiful lake on the Magic Mountain.

Does this look like a good place to stop for a while? Would you like to sit on the bank by the edge of the lake and see what happens? Find a place that looks just right. You might want to take off your shoes and socks and slide your feet into the lake. How does the water feel today?… Notice the place where you're sitting. What does the ground feel like?… What do you notice around you?… What can you smell and what can you hear?… Are there any animals or birds near the lake?… As you sit by the lake you will feel the warmth of the sun on you. There is a feeling of excitement in the air… Something special is about to happen. Wait very quietly and listen. Very faintly you will begin to hear the sound of a bell. It's ringing softly from deep in the lake… As you watch and listen, the surface of the water begins to ripple… The ripples grow larger and larger and

Figure 11.1 John says hello to Cerulean

you can see something moving from deep down in the lake. A wonderful, magical, friendly creature is coming up to see you. It's coming closer and now you can see its head and the top bit of its body has just appeared! My goodness! This is exciting! Can you tell me what it is that you can see?... This most wonderful creature is called Cerulean [*or the children could choose their own name for him*]. He lives at the very bottom of the lake in a magical city. Would you like to visit this city for a little while? Of course, one of the special things about this lake is that as soon as you step in to it you will be able to swim in the most expert way and you will be able to breathe under water without even thinking about it. There is nowhere else in the world where you could do that so it seems too good a chance to miss, don't you think? And don't forget you have your Safekeep with you to protect you. The lake looks very inviting and Cerulean is offering to take you on his back down to the city.

Feel the water as you step into it and hold on to Cerulean's back. Feel what it's like as he swims deeper and deeper into this beautiful lake... Deeper and deeper you go. Very soon now you will be able to see the lights of the city where he lives and you can still hear the bell ringing softly. When you see the city tell me what it looks like today...

Figure 11.2 Cerulean takes John to meet the magician

Are there any other magical creatures around?… What else can you hear besides the bell?… Cerulean is swimming expertly around the city. He is taking you to the House of Good Feelings… And here it is. There is a wonderful calm, happy feeling surrounding this place. What does the house look like from where you are now?… The door is open and you can go in. What does it look like inside?… You can walk around in here. Touch some of the things that you see. What can you feel?… Cerulean has come in with you. He says that somewhere in the house there is a magician who is an expert in [*name the worries or difficulties that the children thought of to bring to the lake*]. In fact there are lots of magicians here, so you have to look for the right room. There are many different doors and each one has a sign on it. Have a wander around until you can find the door that says [*name the worry*] … Have you found it?… Knock on the door and go in to the room. There is a friendly magician sitting on the floor in this room. Can you see him clearly? What does he look like?…

Go and sit near him and tell him why you have come to visit the House of Good Feelings… The magician knows exactly what you need. He goes to a big glass cabinet behind him and he takes down a jar full of a magic powder. From amongst all the hundreds of jars on the shelves this is the one that will be just right for you today. The magician takes a spoonful of the coloured powder, mixes it in a glass of water and gives it to you to drink…. As you drink the potion you

can feel the powder fizzing inside your body as it dissolves. It's a lovely tingly fizzing feeling all through your body.

[*If the worry was to do with an ache or pain*]: As you drink this magic water feel how it is spreading through your whole body and relaxing you so that when you've finished drinking it you will be feeling even better.

[*If the worry was to do with a situation or the child asked for more of a certain feeling*]: As you drink this magic water you can feel that it is spreading through your whole body and filling you up with all the [*confidence, calmness etc.*] that you need.

It's time to thank the magician and leave the House of Good Feelings but you know that you can come back any time you want to find a magician to help you. Cerulean is waiting to take you back to the surface of the lake again. As you swim back together you can hear all the magicians singing. They enjoy their work so much it always makes them happy when someone comes to visit! You are swimming up and up to the surface of the lake... Now you are back by the shores of the lake and can step out onto the ground. As you turn to say goodbye to Cerulean he gives you a special gift from his home in the lake... What has he given you?... Hold it carefully as you watch him dive back down into the glassy blue water. As you stepped out of the lake your wet clothes suddenly became dry and so

Figure 11.3 The magician makes some magic

now you're ready to go home as well. I'll count from ten down to zero, and when I get to zero you'll be back in this room again. Ten...beginning to leave the mountain... Nine... eight... A little nearer home... Seven... six... Even nearer... Five... four... You can feel yourself coming back into this room... Three... Notice the feel of the warmth of the room... Two... Wriggle your toes and fingers... And... one... Open your eyes and have a stretch!

SUGGESTIONS FOR EXPANSION ACTIVITIES

- Invite the children to draw something that they have experienced during the imagework.

- Play a game of 'pass the sound' where each person takes turns to make a sound such as 'bah', 'sssssss' or 'bleh' etc. and the other(s) have to copy it.

- Start off as above but try and remember all the sounds in sequence so that each person has to repeat what he's already heard and then add a new sound.

- Tone the sounds used at the beginning of the session together and see if the children can focus on different areas of their bodies for each tone and 'feel' that area vibrating. (See below for the sequence of toning.) Really intend for that area to vibrate! Remember to start by sitting or standing in a comfortable position and breathing deeply from the diaphragm as explained at the beginning of the session (see also Chapter 2.) The following sequence for toning is that used by Jonathan Goldman, a leading authority on sound healing (Goldman 1995):

 'UH' – located at the base of the spine

 'OOO' – located about three inches below the naval

 'OH' – extending from the naval several inches upwards (to the solar plexus)

 'AH' – centred in the middle of the chest, near to the heart

 'EYE' – located at the throat

 'AYE' – centred in the forehead between and slightly above the eyes

 'EEE' – located at the top of the head.

Note what each of you felt like before you started this exercise and what each of you feels like at the end of it. Remember, if you feel slightly light-headed, tone 'UH' again a few times at the end.

- Invite members of the group to choose a favourite song for everyone to sing.
- Play a selection of short pieces of music and discuss the different feelings and thoughts that the children associate with each piece. Have a mixture of different types of music, for example, very quiet, slow, rousing, fast, loud.

CHAPTER 12

Session Six: Setting Goals

Explanation for facilitator

Session 6 takes the children to the space ship landing stage. They are now at the area of the mountain that corresponds to the centre of the forehead and to creativity, clarity of thought and intuition. The associated colour is indigo. The preparatory activity involves creative movement. The imagework and expansion activities are based on goal-setting. It might be helpful if you talk briefly about this beforehand so that the children can choose a particular goal for themselves. When you reach the part of the imagework where the space ship is taking off I suggest you play gentle music such as *Music From The Pleiades* by Gerald Jay Markoe. The Pleiades are a star cluster and this music was inspired by them.

Preparation

We've visited almost all the parts of the Magic Mountain that I know about now. Only two more to go. Today you've been invited to go to the space station. If you want to, you can go on a space trip to the stars from this station. To get yourself ready for this we're going to play with some colours to find out what they feel like. Did you know that you could feel colours? Remember, as we've visited all the different places on the mountain we've seen lots of different colours – almost all the colours of the rainbow. In each place I expect you felt a little bit different. We started with red. If you were the colour red how would you move do you think? Would you move quickly or slowly? Would you be small and only move in a small space or would you be big and move all over the room? Would the way you move feel heavy or light or somewhere in between? Do you think red would have a sound that goes with it? See if you can move like red. [*Do this for about thirty seconds and allow a similar amount of time for the*

rest of the colours] Now, what about orange? See if you can move around the room like orange [*repeat for yellow, green and blue*].

Here's a new colour now that we haven't seen on the mountain before. It's called indigo. It's a really dark blue like the dark blue of a deep ocean or the dark blue of an evening sky. How would you move if you were indigo?... The last colour of the rainbow is violet. How would it feel to be violet?... See if you can move like violet. Now you choose a colour to move to and I'll see if I can guess which one it is. [*In a group, each child can take turns while the others guess. After this you could talk with the children about the feelings they had with each colour. Did they feel happy, sad, full of energy, calm etc? Or, if you prefer, this could be kept as an expansion exercise to do at the end of the session*]

Now it's time to visit the Magic Mountain again. Find a nice comfortable position... and gently let your eyes close. Breathe in, right down into the bottom of your lungs. Imagine that you are breathing in the colour red. Now imagine that your breath is red and blow it out gently as though you are blowing away a feather in front of you... Now do that again but this time imagine that as you breathe out the air is orange and it can blow that feather even further away... Now your breath is yellow... See how far the feather is going! Now green...blue...indigo and finally violet... And now go back to your regular breathing....

Journeying

[*This has been adapted from an exercise by Dina Glouberman 1989, p.187*] Start to imagine that part of the mountain that we last visited. Do you remember? It was the big lake. This time you are on the other side of it, looking up towards the top of the mountain... You begin to walk slowly along the path... It's not very far to go now... Just in front of you there's a big open space with a huge flat platform on it built of wood. This is the landing stage for the space craft. You're just in time to see it as it comes back from its last journey. If you stand at the edge of the platform and look up into the sky you will see it and hear it as it comes in to land... Can you see it yet?... What sort of a space ship is it? Notice its size and colour and shape. Notice what it sounds like... It's on the landing stage now and someone is stepping out of it and walking away... Now you can see inside the space ship. Is there room for two people in there or just enough for one?... Well, I think it's time for you to go on your journey. Step into the space ship and you will see a really comfortable chair to sit in, with some

controls on a board in front of it and a large window that goes at least half-way around the ship. When you've sat down, have a look at the controls. There are lots of them. There's a button that has a sign under it saying 'to the stars' and one that says 'back to the Magic Mountain'. When you're ready to go all you have to do is press the button for the stars and the space ship will gently take off and head up into the sky. Ready?

You're climbing high up into the sky now, you can see the mountain down below you, it's gradually getting smaller and smaller. Your space ship takes you through the clouds. The sky around you is becoming a deeper and deeper blue and you can see the stars shining ahead of you. You're going high into the place where everything and anything is possible... There are so many stars up here the spaceship has to carefully navigate between them...

Somewhere up here is your own special star and the space ship is going to take you right up close to it so you can see it really well... Have you found it?... Notice all the little details about this very special star as the space ship hovers near it and circles around it... If there is something you have to get done or a goal you want to set for yourself then this star will be able to show you what things will be like for you once you've achieved it. If you've thought of something you can try it out now or, if not, you can come back again another time. Tell me if there is something you'd like to be able to do...

Now, imagine that there is a beam of light shining out from the star in to the sky. It can project pictures on to the sky as though you were at the cinema. As you watch you can see a big screen forming in the sky ahead of you. On to this screen walks a person... it's you! This is you after you've achieved your goal. [*If you know what they are, it would be helpful to elaborate on individual goals at this point. For example 'you've finished your maths test', 'you've learnt how to swim', 'you can ride your new bike', 'you've finished making that model and it's right there beside you'*]

What do you look like on the screen?... What is the 'future you' doing now?... What did you do to make this happen?... What did you need to have or to know so that you could achieve your goal?... How is 'you' on the screen different from you sitting in the space ship?... If the future you could whisper something special to you in the space ship, what would they whisper?... The future you says goodbye and is walking away now. As you watch, the beam of light

from the star starts to get fainter and the screen starts to fade until eventually it has disappeared all together... How are you feeling now?

If you like, you've got plenty of time just to play up here in the stars. You can make your space ship go wherever you want. See what you can find up here! [*Let the children explore in silence for a few minutes and ask them to indicate when they are ready to leave for home again*]

Time now to leave the stars. Take one last look around... Press the button that says 'back to the Magic Mountain' and away goes the space ship, through the deep blue sky... through the floating clouds... slowly and gently back down to the mountain... and landing with a little bump back on the platform.

Figure 12.1 John sets the spaceship on course

As you get out of the space ship notice if you feel any different now to how you felt when you first set off... Now you're walking away from the landing stage... You're walking slowly down the mountain... past the lake, through the woods, past Marigold's home, past the redwood tree and the HugMe tree... When you reach the bottom of the mountain slowly take three deep breaths and feel yourself coming back to the room... Notice the feel of your body... Listen to the sounds around you... Keep your eyes closed for a little while longer while you have a little stretch... When you are ready open your eyes and look around you... Stamp your feet on the floor a bit to bring you properly back down to earth!

Figure 12.2 John explores the stars in his spaceship

SUGGESTIONS FOR EXPANSION ACTIVITIES

- Invite the children to write a letter to themselves from the future to say what they did to make their goal happen. (If writing is difficult they could draw pictures or ask someone to be their 'secretary'.) Collect the letters and post them to the children in a few weeks' time, or whenever appropriate, to help spur them on to complete the goal.
- Invite the children to draw a picture of 'future self', the star or the space ship.

- Suggest that each child makes his special star, for example out of cardboard and silver paper, and put it near his bed or hang it from the ceiling in his bedroom.

- Make a large sky picture – each week the children can add a star to the scene with their name and a few words to explain what they have achieved for example:
 - This week I tied my own shoelaces.
 - I remembered to take my PE kit to school.
 - I made up an imaginative story.
 - I learned a new word.

CHAPTER 13

Session Seven: Meeting the Wise and Loving Being

Explanation for facilitator

So, to the last stage of this particular journey. We are now at the very top of the mountain, relating to the crown of the head and associated with the colour violet. Here the children meet the archetypal image of 'the Wise and Loving Being' (see Chapter 1). The preparation activity involves awareness of positive feelings while the imagework takes the children to a place of peace and calm. The music I like to use for this session is Mike Rowland's *The Magic Elfin Collection* or Philip Chapman's *Keeper of Dreams*.

Preparation

We've explored most of the Magic Mountain now and there's just one more place to visit. In a moment we'll go to the very top of the mountain and meet a wise and loving being who lives at the place where the mountain touches the sky. Just like for all the other parts of the journey we're going to get ourselves ready first. Sit comfortably and close your eyes. We're going to do some gentle breathing while I count slowly. When you're ready, breathe in slowly – one... two... three... Don't let it go just yet. Hold it – one... two... three... And let go gradually – one... two... three.... Breathe in again for three – one... two... three... Hold it there for three – one... two... three... Now let go gently for six – one... two... three... four... five... six... Now we'll do it for the count of nine. When you're ready breathe in for three – one... two... three... Hold it for three – one... two... three. Breathe out gently while I count to nine – one... two... three... four... five... six... seven... eight... nine. [*Do two more 'nine' breaths*] Now forget about your breathing, just let it happen naturally. Imagine that all around you

there is a golden light. It is surrounding you and all the other people in the room. Now imagine that you can feel this light pouring down from above the top of your head. It's coming from way, way up in the air and it's coming down on to the top of your head, some of it is going through your body and some of it is going around and over your body, just like a waterfall of light. Notice how your body is feeling. The golden light feels warm and protective and loving. Now the light is spreading out from the room and is reaching all over the building… and then on to the street… Imagine the light spreading further and further until it fills all of the town and then the whole country… and eventually the whole world, spreading good feelings everywhere… Now notice the part of the light that is around and inside you again and enjoy the nice feeling that it brings…

Journeying

['Meeting the Wise and Loving Being' is adapted from an exercise by Dina Glouberman 1989, p.288] Are you ready now to make the journey to the very top of the Magic Mountain? Your whole body is relaxing now…more and more relaxed…more and more calm….Peaceful and calm… Relaxing even more than you thought you could…. Very peaceful… very calm…[at this point begin to play the music of your choice] Imagine that you are in the field at the foot of the mountain. You go through your special gate and stand for a moment looking up. Now at last you can see the whole of the mountain before you. You can see the colours of the different areas – red, orange, yellow, green, blue, indigo and, right at the top, violet. It is a beautiful day on the mountain. Breathe the wonderful fresh air… Notice the smells… the sounds… the feelings… As you gaze at the mountain you find yourself being lifted gently from the ground as though you are on a magic carpet. Slowly and gently you are carried up the mountain, through all the different colours. You pass through the place where the red flowers and the redwood tree grow, through the place where the orange flowers are and where Marigold lives. You are floating very gently, higher and higher, through the yellows, the greens, the blues and the indigo colours on your way, until you are at the very top where everything is coloured violet. Here you are set down again on the ground. Take some time just relaxing in this beautiful place at the very top of the Magic Mountain…

After a while you notice the golden light is still around you... Sit quietly surrounded by the light and feel how warm it is... You feel as strong as the mountain... It feels as though you *are* the mountain and the mountain is you... You feel very peaceful...

As you watch quietly you will see a wise and very loving being coming towards you through the light. It might be someone you know or someone new, or perhaps an animal. They are here to listen to whatever you want to tell them and to help you in whatever way they can... As they come closer you start to walk towards them... As you come nearer each other, notice what makes this Wise and Loving Being special. Do they have a special light around them? What is it that makes them special? Are they full of happiness, love, knowledge, peace? Look in to their eyes and feel how welcoming they are... You have plenty of time to talk to this Wise and Loving Being. In your mind, ask if they have a name. Say anything that you want to, ask any question, talk about any problem. Just carry on having a conversation with them, talking and listening for as long as feels right...

As you are talking feel how the energy from the Wise and Loving Being is flowing in to you. Begin to feel their special energy as part of you... After a while the Wise and Loving Being holds out a gift for you. Something special to take with you when you leave the mountain... Take the gift in your hands. Look at it very carefully. What have you been given?...

When it feels right, say good bye to the Wise and Loving Being and thank them in whatever way you would like to. Ask them if you can meet again another time.

Now you are leaving the top of the mountain, walking along the path through the violet flowers, walking down the mountain with no effort at all. You go past the space station landing stage, past the blue lake where the magicians live... past the green clearing where you played with the animals... through the yellow flowers... past Marigold's house where Lila is sitting beneath an orange tree... past the redwood tree where the Keeper waves to you... and finally down past the great HugMe tree to the gate... Go through the gate and close it carefully behind you. You are once more back in the field and it is almost time to come home... Everyone on the Magic Mountain is getting ready to go to sleep: all the magicians and the white witches, the Wise and Loving Being, Lila and the other animals, and the Keeper. A peaceful quietness falls over the

mountain as you leave... Stay very still and let the feelings of peace and quiet wash over you...

The most wonderful thing about the Magic Mountain is that it will always be there. You only need to close your eyes and let your imagination take you on the greatest adventures. Whenever you need help with something that is worrying you, or you want to feel more confident or more relaxed, you can talk to any of the animals or people that you have met on the mountain. Just like the mountain itself, they will always be there for you...

When you are ready you can begin to come back to the room again. Keeping your eyes closed, listen to the music and to the sounds of this world going on around you... Gently wriggle your toes and fingers... Begin to be more aware of your body and the feel of your clothes against your skin... When you feel completely back in the room open your eyes and have a good long stretch...

[*Spend some time talking about how it felt to reach the top of the mountain. Perhaps talk about what else you might find there if you go again. One little boy I did this with thought there would be seven doors, each one leading to an exciting adventure!*]

Figure 13.1 Remembering the mountain

EXPANSION ACTIVITIES

As this was the last session of this particular journey on to the mountain, I suggest that the expansion activities all centre on completion of previous projects. For example: finishing collages, adding the finishing touches to a model of the mountain. Discussions can focus on what each child found most helpful and how they might use the ideas themselves in the future. I also recommend that expanding the imagework to cover particular issues (see Appendix A) should begin as soon as possible after this session. Finally, enjoy using imagery in your own life, share it with your children and spread the word!

Appendices

Appendices

Appendix A: One Step Further

A 'free flow' imagework session to look at a particular issue should follow the same format that was used for each part of the journey on the mountain:

1. Set aside a quiet time when there will be no interruptions.

2. Prepare the room and yourself.

3. Introduce the topic. For example: 'In our imagework session today I think it would be helpful to look at the problem of teasing' or 'Let's look at how imagework can help you to plan the talk you have to give'.

4. Take time for a preparatory activity to encourage the children to relax and to facilitate the imagework.

5. Each child 'invites' an image and explores and interacts with it (see instructions below).

6. Emerge from the relaxation.

7. Talk about the experience.

8. If appropriate, brainstorm some ways in which the problem could be resolved. This is equivalent to the children 'mapping' the images back onto what is actually happening for them.

9. Complete the session with an expansion activity such as drawing.

In a session on teasing, for example, Stage 5 could involve visiting a certain part of the mountain to ask for help, perhaps Marigold's 'house of friendship.' For older children who could manage a more in-depth exploration of the problem, the instructions for Stage 5 might go something like this:

Step one

When you're feeling nice and relaxed invite an image to appear in your mind that somehow shows what it's like to be a person who teases others. This image might be an animal, an object or a plant. Whatever comes into your mind first,

let that be your image for a person who teases others. Once you have an image spend a little bit of time finding out about it. What does it look like when you really examine it? Does it move? If so, how does it move? Now become the image. Step into it and see how it feels to *be* the image. As the image, ask yourself: 'What is the best thing about being me?', 'What is the worst thing?' If you could change something about yourself as this image what would you change? What do you want to happen? [*My own image which has emerged, as I'm writing, is of a wolf which I discover is actually a sheep dressed up as a wolf – a twist to the saying 'a wolf in sheep's clothing'! This wolf tries to be fierce but underneath he is a follower who likes to be part of the group. He really feels quite insecure and the wolf's skin is heavy and is making him itch!*]

Now go back to being yourself again. Take a deep breath and step back into being you. Say goodbye to the image. Relax again.

Step two

When you are ready allow an image to come to you that somehow shows what it's like to be teased. The first image that comes into your mind – it might be an animal, a plant or an object. When you have got an image spend some time finding out what it's like. Look at it from all sides. If you want, you can become the image for a while. Feel what it is like to *be* this image. What is the best thing about being the image? What is the worst thing? When you are ready, go back to being yourself again. Take a deep breath and step back into being you, just observing the image.

Step three

Now look at both the images together. Imagine that you are Marigold, or the Wise and Loving Being. If you could give some advice to the two images, what would you say? If you could change something about them or about what is happening, what would you do?

Step four

Imagine that change happening and see what that is like. What do you want to say to the images now?

Step five

When you have finished thank the images and say goodbye to them so that you are ready to gradually come back to feeling more awake. [*Don't be concerned if some children find this approach more difficult to use to begin with. The more they do it, the easier it will become.*]

Appendix B: Relaxation Exercises

1. Progressive relaxation

[*The technique of tensing and relaxing different muscle groups and noticing the different sensations was originally developed by Jacobson (1938). Ask the children to lie on their backs with arms by their sides. Remember to read the following instructions slowly with plenty of pauses.*]

Make yourself comfortable and close your eyes. Spend a few moments just listening to your breathing and feeling the air go in and out of your body… in and out, like waves on the sea shore…You're going to feel what it's like to tighten up different parts of your body and then to relax.

When you are ready very gradually curl the toes of your right foot so that you can feel them getting tight or tense…hold that tightness for a moment…and let go. Feel the difference between what it was like to be tense and what it's like to be relaxed… Now do the same thing again. Gradually curl your toes… Hold them in that position… and relax… Now do the same with your left foot…curl your toes…hold the tension… and relax… And once more…curling them up…hold it…let go. Now, keeping your heels on the ground, bend both your feet up towards your head. Feel the tightness in your legs when you do this… Hold it…and let go…. Feel the difference… Do that once more.

Now think about the top half of your legs…tighten the muscles in the top half of your legs so that you are slightly pushing yourself up from the floor or bed… Really feel the tension… Now relax… Do that once more… Let all the tension flow out. Your legs will roll outwards when they are relaxed. Check how this feels. Notice the difference between what it feels like when your muscles are tense and when they are relaxed. Your legs will begin to feel warm and heavy.

Now think about your back. Slightly arch your back away from the floor or bed… Hold still…and then relax… Do that once more.

Tighten your tummy muscles by pulling your tummy in towards your back… Again hold this for a moment…and then gently let go with a sigh… Now push your tummy muscles outwards. Check how this feels… Let go…

Repeat this once more – first pulling your tummy in…relaxing…and then pushing your tummy outwards…and relaxing again. Make sure that your legs and feet haven't tensed up again while you've been doing this.

Now you're going to move to your hands and arms. Stretch your arms out and feel which muscles you are using… Hold them stiff for a moment… Now let those muscles go floppy and heavy… Do that once more…. Now gently curl your fingers until you can feel the tightness… Let go and feel the difference… Now stretch your fingers out and see how that feels… Let's do both of those things again, curling and stretching your fingers… Let your hands rest lightly by your side now. All the tightness has gone and your arms and hands feel warm and heavy.

Think about your shoulders. Very gradually and gently raise your shoulders towards your ears. Feel what that's like… See if you feel more tightness on one side than the other… Let go gently… Now let go even more than you thought you could… Do this once more… Raise your shoulders towards your ears…hold the tightness…and let go… and now let go even more.

Now think about your neck. Slowly and gently drop your head towards one shoulder, just far enough to feel the pull of the muscles on the other side… Now slowly move your head back to the middle…and now over to the other side. Feel the tension in your muscles…and now gently back to the middle again. Check that you feel comfortable. If not, try doing that again.

Now gently close your back teeth together. Hold them closed very lightly…and let go. Press your lips together firmly and then let go… Press your tongue against the roof of your mouth and again let go… Your tongue is now resting on the floor of your mouth, your teeth are slightly apart and your lips are resting lightly together.

Think about your eyes. Close your eyes even more tightly than you have already closed them… Now let go again… Feel the difference.

Now wrinkle your nose…and let go.

Raise your eyebrows as though you were surprised…let go… Now frown and feel which muscles you are using…and relax.

Now, instead of thinking of yourself in parts, feel your whole body relaxing, sinking into the floor. With each breath you are breathing out the tightness and breathing in relaxation. Feel the breath go in through your nose, down through your windpipe and into your lungs. Feel it filling your lungs… Feel your breath as the air leaves your lungs and travels out through your nose. Just notice your breathing for a while. Let it happen naturally but feel the flow of air. With each breath out you will feel more relaxed…and more calm… You will feel warm and perhaps a little sleepy. If thoughts come into your head just let them pass through then go back to feeling your breathing. Notice how your body feels

different now. Enjoy this feeling for a few minutes. [*Allow the children to rest quietly for a while.*]

When you are ready gently start to move your fingers and toes... Very gently rock from side to side just a little bit... Have a yawn and a stretch... When you are ready, open your eyes gently and get used to the room again... Bend your knees and roll over onto your side before slowly sitting up.

2. Body Scanning

[*This type of relaxation works by focusing the mind on different areas of the body and encouraging awareness of what that area of the body feels like. (It is an exercise commonly taught as part of mindfulness meditation — see, for example, Tart 1994 or Kabat-Zinn 1996.) Quite often if we try to relax, we try too hard! In our efforts to relax we actually set up more tension. By observing what the body is doing there is inevitably a natural tendency to simply allow any areas of tension to relax and release. It is a good exercise for children (and adults) to do when they find themselves becoming preoccupied by worries, plans and concerns. It can be done lying down or seated.*]

Let your eyes close gently and settle yourself into a comfortable position. I'd like you to think about your right foot and just notice what it feels like. It might be warm or cold. It might be numb or itchy. Just notice whatever you can feel.

Now think about the lower part of your right leg. Let your attention leave your right foot and just move very easily to your right leg. Notice whatever feeling is there just at this moment... Now move up to your knee and the upper half of your right leg and notice whatever feeling is there... Now to your right hand. Feel what's happening in your right hand... Now think about the lower part of your right arm and feel what's happening there... Whatever is there, just notice it... Now do the same with the upper part of your right arm. Remember there are no right or wrong feelings. Whatever you can feel is okay...

Go across your body now to the upper part of your left arm... Now down through your elbow to the lower half of your left arm... And now your left hand and fingers... Now the upper half of your left leg, notice whatever is happening there... And the lower half of your left leg... And now down into your left foot... Now notice both your legs and both your feet at the same time... Now your arms and hands as well as your legs and feet... Start to listen to whatever sounds there are around you... When you feel ready, open your eyes and look around you. Lie or sit quietly for a short while before stretching and slowly getting up...

3. A 'calm down' relaxation

[*This has been adapted from an exercise by Jane Madders. In panic situations, breathing tends to become shallow and fast. If children can learn to take charge early on and bring their breathing back under their control this will help them to regain a feeling of calm more easily. For this quick relaxation to be effective they should already have experienced more detailed methods*]

Explain to the children that as soon as they notice themselves getting tense or worried they should say to themselves: 'Calm Down'. That means telling their bodies to stop worrying.

They should then focus on their hands as they breathe in (this doesn't have to be a big deep breath, just normal breathing) and, as they breathe out very slowly, they should allow their hands to relax. On the next breath they focus on their shoulders, and as they breathe out they allow their shoulders to relax. Finally they focus on their jaws and allow their jaws to relax as they slowly breathe out. After two or three more calm breaths they continue what they were doing.

Appendix C: Breath Control Exercises

[You will need to demonstrate the next two exercise for the children as they take quite a bit of practice!]

1. Energizing breath

- Sit upright in a high backed chair so that your body is well supported and relaxed.
- Breathe naturally for a while, just feeling the rhythm of your breath.
- After a few breaths, press your left nostril closed with your thumb and inhale through your right nostril. Keep the natural rhythm of your breath.
- Release your thumb; close your right nostril with your forefinger and exhale through your left nostril.
- Without changing fingers, inhale through your left nostril.
- Change fingers. Exhale through the right nostril.
- Inhale through the right and exhale through the left and so on. Repeat the whole sequence ten times.

This exercise is good for 'clearing the head' and is effective for panic attacks and headaches.

2. Extending exhalation

- Sit erect and well supported; your chest and head in a straight line; shoulders slightly back; hands resting easily in your lap.
- Inhale slowly as you silently count to three (one… and… two… and… three). Remember to breathe from your diaphragm.
- Hold for the count of three.
- Exhale slowly through your nostrils, counting to six.
- Count to three again before inhaling.

- Continue for about three minutes.

The reason for making the exhalation longer than the inhalation is that breathing in involves muscle contraction, so the heart and metabolism speed up slightly. Breathing out involves relaxation of the muscles and the heart and metabolism slow down slightly. The duration of the exhalation can be slowly increased as you practise this until you are exhaling for the count of fifteen or more. The important thing is to feel the rhythm rather than to try and increase the capacity too far.

3. Combining breath control and imagery

[*Ask the children to sit in a comfortable, upright position.*] As you breathe in imagine that you are breathing up the back of your body from the ankles to the top of your head. Pause for the count of three. Then as you breathe out, breathe down the front of your body, sweeping under your feet. Repeat this six more times, remembering the next time you breathe in to imagine that you have moved slightly further away from your body into the next level, so that when you reach the seventh inbreath you are sweeping a wide circle around your body. Really let go each time you breathe out, releasing the tension from your body. Take your time with this. There is no need to rush it.

Now the next time you breathe in, breathe up the right side of your body from the feet to the top of your head, and down the left hand side of your body as you breathe out. Again, do this in a circular movement sweeping under your feet and moving away from your body in a circle that gets bigger and bigger with each breath. Do this for seven breaths, remembering to pause after breathing in each time.

[*This exercise works well if you imagine the seven colours of the rainbow as you breathe, starting with red close to the body and finishing with violet.*]

Appendix D

Certificate of Excellence

Awarded to

For outstanding performance in:

Signed:

Date:

Appendix E: Further Information

Suggested music

Chapman P.(1987) *Keeper of Dreams*. New World Cassettes.

Chapman, P. (1990) *Radiance*. New World Cassettes.

Kitaro (1985) *Best of Kitaro* (includes 'Morning Prayer'). Kuckuck Schallplatten.

Markoe, G. J. (1989) *Music from the Pleiades*. Astromusic.

Oldfield, T. (1986) *Cascade*. New World Cassettes.

Oldfield, T. (1991) *Spirit of the Rainforest*. New World Cassettes.

Rowland, M. (1985) *Silver Wings*. New World Cassettes.

Rowland, M. (1989) *The Magic Elfin Collection*. New World Cassettes.

Suggested resources for movement and relaxation

Payne, H. (1997) *Creative Movement and Dance in Groupwork*. Bicester: Winslow.

Schneider, M. and Schneider, R. (1995) *Move and Relax with Music*. Cambridge: Green Submarine Ltd.

Useful addresses

Imagework
92 Prince of Wales Road
London NW5 3NE

Contact the address above for the Skyros Institute and The Imagework Association, as well as details of courses and local practitioners.

Laban Centre for Movement and Dance
Goldsmiths College
Laurie Grove
London SE14 6NW

References

Bandler, R. and Grinder, J. (1990) *Frogs into Princes. The Introduction to Neuro-Linguistic Programming*. Enfield: Eden Grove Editions.

Benson, H., Kotch, J.B., Crassweller, K.D. and Greenwood, M.M. (1977) 'Historical and clinical considerations of the relaxation response.' *American Scientist 65*, 441–5.

Bettelheim, B. (1978) *The Uses of Enchantment*. Harmondsworth: Penguin.

Bornstein, E. M. (1988) 'Therapeutic storytelling.' In Rothlyn P. Zatiourek (ed) *Relaxation and Imaginary Tools for Therapeutic Communication and Intervention*. London: W.B. Saunders.

Chodorow, J. (1994) *Dance Therapy and Depth Psychology: The Moving Imagination*. London and New York: Routledge.

Clark, H. H. and Clark, E. V. (1977) *Psychology and Language: An Introduction to Psycholinguistics*. New York: Harcourt Brace Jovanovich, Inc.

Faber, A. and Mazlish, E. (1982) *How to Talk so Kids will Listen and Listen so Kids will Talk*. New York: Avon.

Ferguson, M. (1980) 'Focusing: a tool for changing times.' In E. T. Gendlin (ed) (1988) *Focusing*. New York: Bantam.

Gardner-Gordon, J. (1993) *The Healing Voice*. Freedom, CA: The Crossing Press.

Glouberman, D. (1992) *Life Choices and Life Changes Through Imagework*. London: Aquarian/Thorsons.

Goldman, J. (1995) *Healing Sounds: The Power of Harmonics*. Shaftesbury: Element.

Hillman, J. (1990) 'The poetic basis of mind.' In T. Moore (ed) *The Essential James Hillman*. London: Routledge.

Houston, G. (1993) *The Red Book of Gestalt*. London: The Rochester Foundation.

Jacobson, E. (1938) *Progressive Relaxation*. Chicago: University of Chicago Press.

Johnson, R. (1989) *Inner Work: Using Dreams and Active Imagination for Personal Growth*. New York: HarperSanFrancisco.

Jung, C.G. (1916) 'The transcendent function.' *Collected Works Vol. VIII* (1975). Princeton: Princeton University Press.

Jung, C.G. (1949) Foreword In E. Neumann, (1990) *Depth Psychology and a New Ethic*. Boston and Shaftesbury: Shambhala.

Jung, C.G. (ed) (1978) *Man and His Symbols*. London: Pan Books (Picador edition).

Kabat-Zinn, J. (1996) *Full Catastrophe Living: How to Cope with Stress, Pain and Illness Using Mindfulness Meditation.* London: Piatkus.

Kelly, G.A. (1991) *The Psychology of Personal Constructs.* London and New York: Routledge.

Macbeth, J. (1991) *Sun over Moon: A Course in Creative Imagination.* Bath: Gateway Books.

Madders, J. (1987) *Relax and be Happy: Techniques for 5–18 Year Olds.* London: Unwin.

Miller, A. (1991) *The Drama of Being a Child.* London: Virago

Murray, M. (1991) Foreword to J. Macbeth, *Sun over Moon: A Course in Creative Imagination.* Bath: Gateway Books.

Olness, K. (1993) 'Self-regulation and conditioning.' In B. Moyers, (ed) *Healing and the Mind.* London: Aquarian/Thorsons.

Ravenette, A.T. *A Drawing and its Opposite: An Application of the Notion of 'Construct' in the Elicitation of Children's Drawings.* (Unpublished paper.)

Robertson, P. (1996) *Music and the Mind.* London: Channel 4 Television

Robinson, G. and Maines, B. (1989) 'A self-concept approach to dealing with pupils.' In R. Evans, (ed) *Special Educational Needs 'Policy and Practice'.* Blackwell Education in association with National Association for Remedial Education.

Shone, R. (1987) *Autohypnosis.* London: Thorsons.

Singer, J. (1973) 'Play with social materials.' Reported in C. Garvey, (1982) *Play.* Somerset: Fontana/Open Books.

Stevens, A. (1991) *On Jung.* Harmondsworth: Penguin.

Stevens, J. O. (1989) *Awareness.* London: Eden Grove Editions.

Storr, A. (1989) *Solitude.* London: Fontana (Flamingo edition).

Tart, C. (1988) *Waking Up: Overcoming the Obstacles to Human Potential.* Shaftesbury: Element.

Tart, C. (1994) *Living The Mindful Life.* Boston & London: Shambhala.

Further Reading

Dwivedi, K.N. (ed) (1997) *The Therapeutic Use of Stories*. London and New York: Routledge.

Page, C. (1994) *Frontiers of Health*. Saffron Walden: C.W. Daniel Company Limited.

Saint-Exupéry, A. (1974) *The Little Prince*. London: Pan Books in association with Heinemann.

Satir, V. (1991) *Peoplemaking*. London: Souvenir.

Wiseman, A.S. (1989) *Nightmare Help*. California: Tenspeed Press.

Subject Index

(references in italic indicate figures)

Author Index